Victorian Photographers at Work

John Hannavy

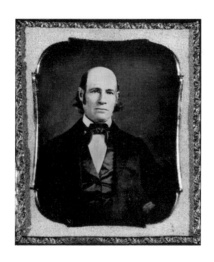

SHIRE PUBLICATIONS

Published in 1997 by Shire Publications Ltd, Cromwell House, Church Street, Princes Risborough, Buckinghamshire HP27 9AA, UK.
Copyright © 1997 by John Hannavy. First published 1997. Number 11 in the History in Camera series. ISBN 0 7478 0358 7.
John Hannavy is hereby identified as the author of this work in accordance with Section 77 of the Copyright, Designs and Patents Act, 1988.

Printed in Great Britain by CIT Printing Services, Press Buildings, Merlins Bridge, Haverfordwest, Pembrokeshire SA61 1XF.

British Library Cataloguing in Publication Data: Hannavy, John. Victorian photographers at work. – (History in Camera; 11) 1. Photography – Great Britain – History – 19th century. 2. Photography – Great Britain – Equipment and supplies – History – 19th century. 3. Photographers – Great Britain – History – 19th century. I. Title 770.9'41'09034 ISBN 0 7478 0358 7

Cover: *The Ascent of the Pyramid of Cheops. See page 68.*

Opposite: *A horseman photographed on Scarborough beach c.1870. Sixth plate ambrotype by local photographer Thomas Harrison, whose studio was adjacent to South Beach.*

Below: *A contemporary engraving of the interior of a typical wet collodion photographer's portable dark tent, c.1855. Everything the photographer needed could be carried packed up inside this collapsible darkroom.*

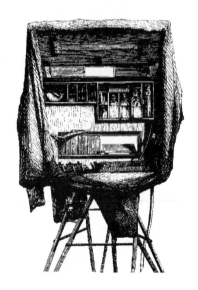

Contents

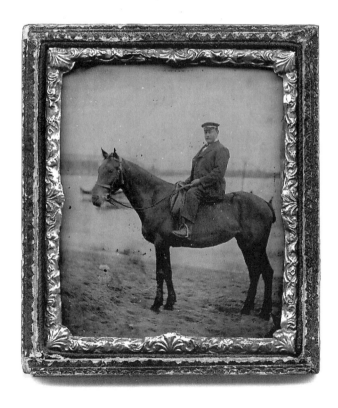

Advertising trade card for James Keeley's studio in Wood Street, Liverpool. Keeley is listed at this address in local trade directories in 1862. By the late 1870s his address is given as 16a Albert Street, Liverpool, premises which had been occupied in the early 1870s by George Keeley, perhaps his father or brother.

An interesting aspect of this card is Keeley's claim that his photographs are 'taken on paper', a reference not to the negative process but to the fact that he was producing albumen prints, perhaps carte de visite photographs, by 1862, rather than the daguerreotypes and ambrotypes which had been produced in most studios up to that time.

A CORRECT
LIKENESS
With Frame and Glass included.
For 6d.,
AT KEELEY'S
PHOTOGRAPHIC
ESTABLISHMENT,
62, WOOD ST.,
Off Slater Street, Bold Street,
LIVERPOOL.

Photographs taken on Paper.

Right and opposite: John Frederick Timms operated a studio at No. 31 High Holborn, London, from 1857 until at least 1873. From 1874 he also had studios in Camden Road and in Cheapside. This advertisement (right) dates from 1861 and backs an ambrotype given as an 1861 Christmas gift. (Prince Albert died in 1861 and references to his patronage were quickly removed from advertising as a sign of respect.)

Earlier examples of Timms's trade cards (opposite) show that significant development of the buildings adjacent to his premises had taken place since he moved there in 1857.

In this later illustration, there is no sign of the large glasshouse studio visible on top of the building in his earlier advertisements.

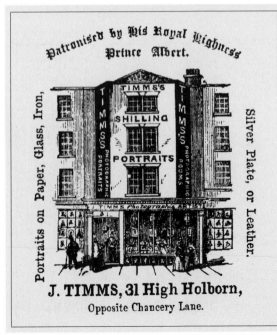

Patronised by His Royal Highness Prince Albert.

Portraits on Paper, Glass, Iron,

TIMM'S

SHILLING

PORTRAITS

Silver Plate, or Leather.

J. TIMMS, 31 High Holborn,
Opposite Chancery Lane.

Introduction

The first professional photographic studio in Britain was opened by Richard Beard on 23rd March 1841, in a specially built glasshouse on the roof of the Royal Polytechnic Institution in Regent Street, London. He had acquired a licence to use the French daguerreotype process from the inventor, Louis Jacques Mandé Daguerre, through his British agent Miles Berry, at a reported fee of £150 per year. At the time the average skilled man earned no more than 10 shillings (50p) per week, so the true scale of that licence fee can be appreciated. To consider paying such a large annual fee for the right to use an untried process is evidence either of Beard's vision or of his foolhardiness.

By June 1841 he had bought out Berry's patent rights and was effectively in control of the process throughout England and Wales – with the exception of the London-based French photographer Antoine Claudet, who had personally acquired his licence from Louis Daguerre himself. Thus Britain's first two studios, both in London, established competition from the outset of commercial photography.

It fell to the first generation of photographers to create and develop the market for their new product. While Richard Beard saw the huge

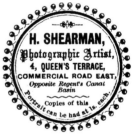

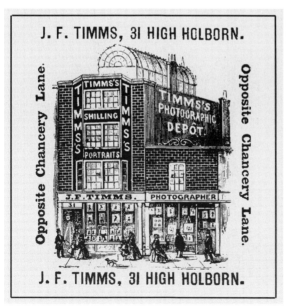

Above: *Henry Shearman is first listed at his Queen's Terrace address in 1862, and his studio was last listed at those premises in trade directories in 1867. In 1868 he moved from Queen's Terrace to nearby Regent Street, where he remained until at least 1873. The ambrotype with which this label was found was cased in a ninth plate octagonal union case. Shearman's customers were apparently able to meet the high cost of such packaging.*

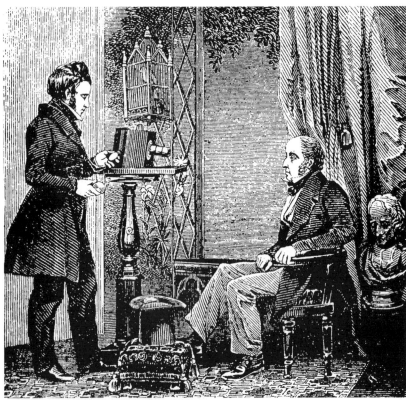

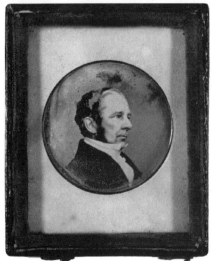

Above: *This early woodcut shows the London photographer Jabez Hogg making a daguerreotype portrait of William Johnson in 1843. The location is reported as being Richard Beard's Parliament Street studio, which had opened in the previous year. The original daguerreotype is now in the National Museum of Photography, Film and Television. The woodcut appeared as an illustration in Hogg's book 'A Practical Manual of Photography', originally published in 1843. Hogg has the lens cap in his right hand and is timing the exposure with a watch held in his left hand. Above the camera, a bird in a cage served as a focal point for his portraiture subjects, who responded to his entreaties to 'watch the birdy'.*

Left: *An early ninth plate daguerreotype portrait produced by the Photographic Institution of Salop, one of the early studios licensed by Richard Beard.*

potential market for portrait photography – if he could develop and control it carefully – other uses for the new medium may have been less immediately apparent. Yet within a very few years photography was being used in a wide range of ways, often as an end in itself – the family portrait – but also as a means to an end in recording the great industrial, architectural and technological developments of the day.

In the early 1840s Alexander Gorton, a forward-looking Scottish civil engineer, proposed to the Institution of Civil Engineers that photography could serve their industry well as a means of recording progress and change, enabling 'views of building works, or even of machinery when not in motion, to be taken with perfect accuracy in a very short space of time and with comparatively small expense'.

In the 1850s Sir William Crookes at the Ratcliffe Observatory in Oxford applied photography to astronomy, while others used the new medium to chronicle the progress of great shipbuilding projects. Some saw the potential for using photographs as educational tools, while yet others saw the huge potential market if the public could be persuaded to buy and collect images. Their innovation in establishing new reasons

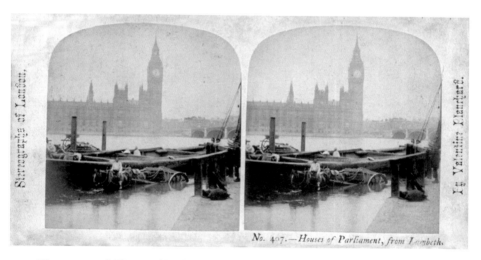

No. 407.—Houses of Parliament, from Lambeth.

The stereo card 'Houses of Parliament from Lambeth' was taken in the mid 1860s by the London photographer Valentine Blanchard, number 407 from his series 'Stereographs of London'. Blanchard first appeared in London trade directories in the late 1850s, with an address at 147 The Strand. By the mid 1880s he had operated studios at seven addresses in central London and Camden Town. Better known for his portraits, he nonetheless produced hundreds of stereoscopic views for the London tourist market which were sold through other London studios as well as his own. This card was sold by Paul Emile Chappius from his studio and shop at 69 Fleet Street. Chappius was at that address from 1860 until at least 1872.

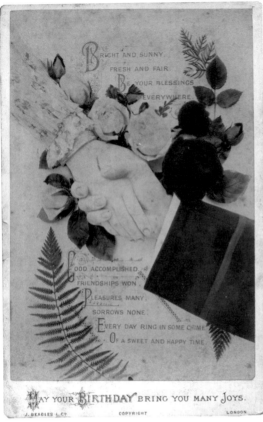

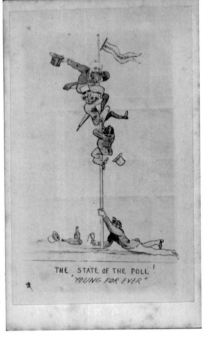

Right: *Edward Steele of Wisbeach (sic) produced this carte de visite copy of a political cartoon in the 1860s. The cartoon focused on the typical Victorian view of politicians and has overtones of drink, greasy poles and impropriety. The original cartoon was drawn on a large sheet of folded paper, the creases of which can still be discerned.*

Above and opposite page: *Some of the many uses to which photography was applied in its first three decades.*

for buying photographs was remarkable.

 As long as access to photography was restricted either by high price or by the unique nature of both the daguerreotype and the ambrotype, the development of markets was slow and limited. But progress accel-

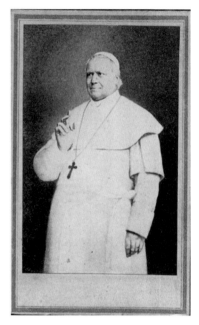

Below: *The 'post mortem' photograph was often the only visual reminder of a lost child. Photographer Gordon Forsyth made this carte de visite of a child recently drowned in a pool in the mid 1870s. The post mortem portrait originated with the daguerreotype in the 1840s and was much more common in the United States than in Britain. Of the value of such photographs, the magazine 'Photographic Notes' wrote in the issue of 9th July 1875: 'the fruits of his work are often the only material consolation which comes to the bereaved friends. It is work not only that cannot be shirked, but must not even be delayed for it is well known that the faces of deceased persons alter for the worse within a day or two of their deaths.'*

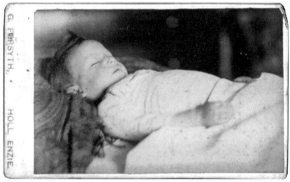

Above: *Cartes de visite of royalty, clergy and the rich and famous from across the world fuelled one of photography's greatest collecting crazes. This is Pope Pius IX, from a mass-produced carte from the early 1870s.*

erated when costs became lower with the advent of the wet collodion glass negative and the albumen paper print made from it.

Stereoscopic or 3-D photography gained immense popularity in the mid to late 1850s and spawned photography's first illustrated magazine, *The Stereoscopic Magazine*, through which the stereo collector acquired three new views with each issue. As almost every middle and upper class family had a stereograph, the market for these 3-D views was considerable. The greatest photographers of the day, including Roger Fenton, produced views for this magazine.

The affluent could purchase the works of Sir Walter Scott and other writers with real photographic illustrations, each print pasted by hand to the pages of the book.

In the 1860s and 1870s photographic publishing companies photographed every tourist location of note and the resulting view prints,

T. A. Cotton

Maidens and Matrons, St. Kilda. 65

The West Coast of Scotland. G. W. W.

Above: *For the magic lantern, George Washington Wilson and others produced lantern slides showing their customers people and places well outside their personal experience.*

Left: *Through Roger Fenton's photography, the treasures of the British Museum became available for the first time to researchers worldwide.*

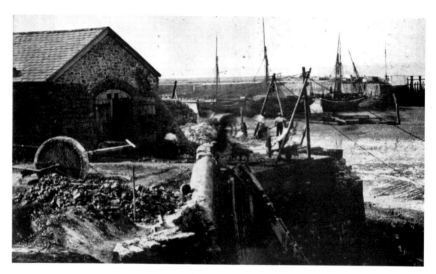

James Date's ambrotypes chronicled the rebuilding of Watchet Harbour after a storm in 1861.

forerunners of today's picture postcards, became widely available, the obvious mementoes with which to return from a holiday.

As the market for photography grew, so did the number of people who aspired to make a living out of the new medium. From the two studios which opened in London in 1841, over two and a half thousand photographers had advertised their services in the capital alone by the end of the century. In that same period Manchester had over eight hundred, Glasgow over five hundred, and Liverpool and its environs well over one thousand. The huge legacy of images which they have passed down into our care gives us a unique insight into life in Britain during Victoria's long reign.

The daguerreotype studio

It is often written that daguerreotype portraiture was restricted to the production of small, intimate and finely detailed images, preserved for us today in their small leather cases. While the majority of daguerreotype portraits were quarter plate or smaller, the earliest outfits were designed for the production of whole plate photographs.

The daguerreotype process has been described as photography's 'false start', for very little of the chemistry or the manipulation which the daguerreotype photographer had to master is still in use today, but such a description is unfair when applied to a process which lasted for over two decades and produced a significant proportion of the rich photographic heritage we enjoy today. While it was the negative/positive process based on paper and glass, rather than the daguerreotype's direct positive image, which evolved into today's mass medium, it was the daguerreotype which established the portraiture studio and the public habit of being photographed.

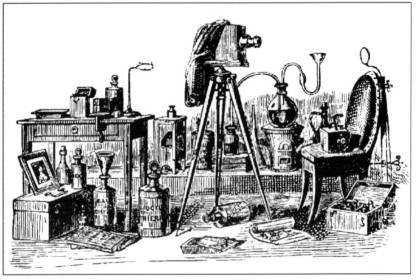

This French illustration shows some of the paraphernalia needed by the photographer using the daguerreotype process. On the table are a box of plates, a plate holder, a bottle of cleaning solution, a buffing pad and some rouge, with a plate vice fixed to the front of the table in which to hold the plate while cleaning it. The developing box stands between the table and the sliding box daguerreotype camera. To the right is the chair in which the subject would be seated, complete with an adjustable head clamp fixed to the back.

The daguerreotype was sold as the logical successor to the long-established miniature painting and, as a result of its high price, it originally sold to the same strata of society. With a cased quarter plate portrait selling for twice the average skilled man's wage, photography was an expensive commodity. The huge licence fees charged by Richard Beard for rights to use the process, initially exclusively within a specified area, may have been partly responsible for the high prices, but they appear to have done little to suppress demand.

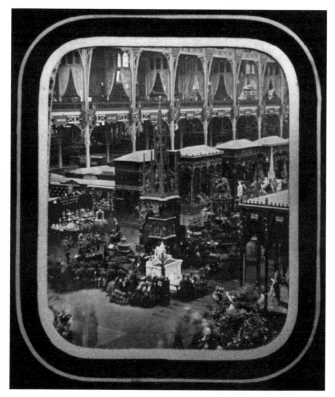

One half of a pair of stereoscopic daguerreotypes of the 1855 Paris Exposition Internationale, showing the interior of the main exhibition hall. The photographer is unknown.

The daguerreotype was, by this time, slowly yielding its long-held supremacy to the wet collodion negative and its easily duplicated paper print. Albumen paper prints and albumen-on-glass stereoscopic diapositives of the exhibition were produced in significant numbers and are still relatively common today.

Despite significant advances in sensitivity during its fifteen years of popularity, the daguerreotype was clearly still not well suited to interior photography in 1855, and the exposure for this unique image was obviously rather long – the figures in the bottom of the frame show considerable signs of movement.

SOLD BY *Jn*

T. CHAPMAN BROWNE,

Bible and Crown, Market Place, Leicester,

BOOKSELLER, PRINTSELLER, MUSICSELLER,

BOOKBINDER,

PRINTER, AND STATIONER.

PATENT PHOTOGRAPHIC OR DAGUERROTYPE
PORTRAIT ESTABLISHMENT.

County Subscription Library—Agricultural Library.

*Agent to the Freemasons' General Life Assurance, and
the County Hail Storm Insurance Companies.*

Top left: *Thomas Chapman Browne, in partnership with Joseph Jenkins Hewitt, opened Leicester's first photographic studio in the Bible and Crown printing works, 36 Market Place, Leicester, in 1844. Their partnership lasted for four years before Thomas Browne became the sole proprietor in 1848.*

Typically for the period, photography, even in a city the size of Victorian Leicester, did not produce sufficient income. Browne, therefore, advertised a wide range of services to his customers, as can be seen from his trade label from about 1850.

It was quite common for photographers of the period to advertise multiple occupations: 'photographer and beerseller' was common in the Lancashire cotton and mining towns, while 'photographer and barber' and even 'photographer and undertaker' have been identified. Thomas Chapman Browne, as printer, bookseller, musicseller, bookbinder, printer, stationer, photographer, librarian and insurance agent, must have been one of the most 'multi-skilled'.

Browne probably had his glasshouse studio on the roof of the printing works or in the rear yard.

The label, which was fixed beneath the image in the base of the burgundy leather case, is illustrated actual size. From 1867, Browne's address, still identified as the 'Bible & Crown', is given as 39 Market Place.

Centre left: *Portrait of an unknown gentleman, ninth plate tinted and gilded daguerreotype by Thomas Chapman Browne. Reproduced actual size.*

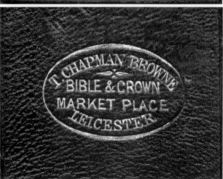

Bottom left: *Browne's burgundy cases, typically for the period, were embossed and gilded with his name and address in an oval plaque.*

Richard Beard was largely self-taught. He had learned the rudiments of the American version of the process and had subsequently acquired the patent rights for the daguerreotype as a purely commercial undertaking. Whatever his beginnings, however, he was responsible for some significant advances in the chemistry and manipulation of the process, and for some of the most significant daguerreotype patents.

Elsewhere in Europe, other aspiring photographers had learned their craft direct from the inventor. Into that group fell, amongst others, Gustav Oehme, whose studio was in Jagerstrasse in Berlin, and Antoine Claudet in London, whose licence to practice the process also came from Louis Daguerre himself, placing him beyond Beard's control.

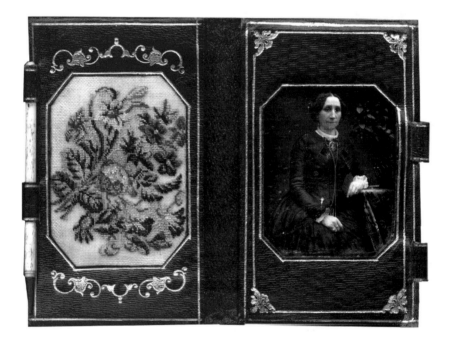

Sixth plate daguerreotype in a decorated and embroidered wallet, 1851. This wallet is made of hand-tooled leather, with embossed and gilded decoration. The tapestry panel is in silk threads on fine canvas. The closure is an ivory-shafted lead pencil, and the wallet contains a notebook, with shot-silk covers, bearing the inscription 'To Alexander Douglas from his Mother, May 10. 1851'. From the notes in the notebook, Alexander Douglas appears to have worked in a shipping office in Leith, the port of Edinburgh. While daguerreotypes were often found in jewellery, particularly brooches and lockets, it is highly unusual to find photographs being used in items such as wallets.

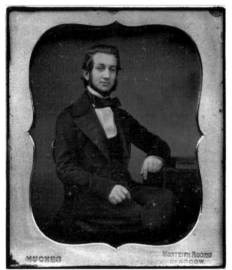

Sixth plate daguerreotype, tinted and gilded, by Cornelius J. Hughes, taken between 1848 and 1856, at his studio in the Monteith Rooms, 67 Buchanan Street, Glasgow. The image was supplied in a burgundy leather case, fitted out with deep green velvet pad and trim. Hughes took over the operation of a studio originally established in 1846 by John Bernard. Both Bernard and Hughes are listed at the address in 1848 and 1849.

The French and American variants on the daguerreotype process were markedly different. The most obvious difference was the design of the cameras used to make the pictures. While Daguerre's original design had many of the characteristics familiar in today's equipment – lens at the front, plate holder at the back – the preferred American style was radically different. Rather than a lens, early American cameras had an aperture at the front and a concave mirror inside the camera to reflect the image back on to a plate held at the front below the aperture. This had the effect both of permitting more light to enter the camera and reach the plate, shortening exposure significantly, and, importantly, of correcting the 'reading' of the picture. Early portraits taken using lenses produced images which were laterally reversed, with lettering reading the wrong way round, buttons on the 'wrong' sides of jackets and wedding rings on the wrong hand! To correct that problem, many cameras were fitted with a correcting prism over the lens. The same problem is also found in many ambrotypes produced in the 1850s and 1860s.

The production of successful daguerreotypes required a high level of technical and chemical skill as well as an eye for a picture. The daguerreotype photographer was manufacturer and processor as well as photographer, being required to undertake almost every stage of the preparation and manipulation of the process himself.

In photography's earliest days, there was no perceived distinction

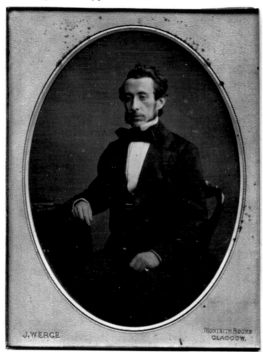

Quarter plate daguerreotype, tinted and gilded, by John Werge, taken between 1856 and 1859. Werge was successor to Cornelius Hughes at the Monteith Rooms studio in Glasgow. Both men stamped their names and addresses on to their brass matts using a hand-held die: the 'Monteith Rooms' address on both images has been stamped with the same die.

The first photographer to set up a studio in Buchanan Street, Glasgow, was John Edwards, who had served his apprenticeship at Antoine Claudet's Adelaide Gallery in London. As Edwards would have needed a licence from Richard Beard to open a studio in England or Wales, he elected instead to move to Scotland, where Beard's patents held no sway. His studio, at number 43, opened briefly in late 1842. Many other photographers had the same idea, and at one time there were many more photographers working in Glasgow than in London. Local trade directories list at least eight photographers establishing themselves in the city centre during the 1840s. They were all attracted by the freedom from licence fees, and the potential of large profits while the public clamour for photography grew in strength.

In addition to Bernard and Hughes at the Monteith Rooms, and Edwards at number 43 Buchanan Street, also established in the 1840s were three studios operated by a Miss Borthwick, listed between 1846 and 1850, two studios run by William Low & Son in Gordon Street and Trongate, and others by Mr E. Pickering in George Street, James Robertson in West Nile Street, and Hugh Treffrey in Union Street. With that level of competition, it is hardly surprising that few of them were long-lived. The first, Edwards, moved on after only a few months, opening a studio in Dumfries in March 1843, and another in Stirling later that same year.

Of the ten central Glasgow addresses at which photographers were listed in the 1840s, that of Edwards was the first to close, despite his advertising that, on the roof of number 43, he had 'a handsome saloon, erected for the purpose, so that the light of day, which acts to him the part of a pencil, may have free and uninterrupted access'.

between the preparation of the plates, their exposure and subsequent processing. The darkroom (a term first mentioned in the original 1839 daguerreotype patent filed by Miles Berry in London on Daguerre's behalf) was the centre of all the manipulative activities both before and after exposure. Thus there was usually no distinction seen between the equipment used to prepare and sensitise the plates and that used to expose them. Complete outfits were offered for sale from the earliest days, containing everything that the aspiring photographer would need to set up and practise the 'black art'.

Today's photographer would recognise little in the daguerreotype outfit of the 1840s, save for the camera and the bottle of 'hypo' used to fix the plates – and if the camera was a reflecting instrument, perhaps not even that! A considerable array of equipment was needed to clean, polish, coat, expose and process the silvered copper plates on which the images were made. The daguerreotypist had to understand the workings of plate vices, rouge, polishing sticks, 'fuming boxes' for sensitising the plates, heated mercury developing boxes, and a range of chemicals.

One of the first attempts to relieve the photographer of some of the preparation was the marketing of pre-silvered daguerreotype plates. It was not initially successful. Very few photographers were willing to trust the commercial product; most preferred either to silver their own copper plates or to re-silver the commercially produced ones.

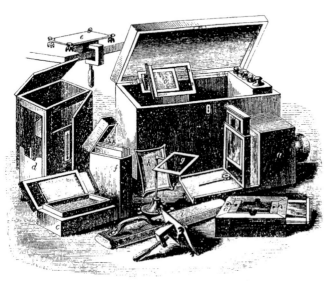

This portable daguerreotype outfit, manufactured in France, was sold in Britain by John Griffin of London, who advertised regularly in the back pages of several contemporary handbooks on photography, the most important of which was Robert Hunt's 'Manual of Photography' published in the 1850s. In this outfit, the sliding box camera, dark slides and plate holders, fuming box, developing box, buffing pad, plate rack, vice and all the necessary chemicals were transported in a fitted carrying case.

Anthony's 'condensing mercury bath' was considered to be one of the most efficient means of developing the daguerreotype.

For the photographer who wished to retain personal control over every stage of the process, this equipment was used to achieve a good silver coating on the copper plate by electrolysis. Some photographers coated their plates completely themselves, while others used this device to 'improve' commercially available plates.

The daguerreotype plate had to be held firmly in place while it was cleaned and polished. A variety of gripping devices was available from the earliest days.

Although the majority of the daguerreotypes which have survived to this day are quarter plate or smaller, the original cameras advertised for the process were full plate size. It is ironic, when considering today's often published assertion that calotypes were large and daguerreotypes small, to learn from contemporary sources that early calotypes were often quite small, while early daguerreotypes were often quite large! Indeed, Fox Talbot's first calotype negatives and Daguerre's first daguerreotypes were probably about the same size! It was undoubtedly the small intimate portrait, however, which was the key to the daguerreotype's success.

The basis of the daguerreotype was a sheet of silver-coated copper, and the success of the image was dependent upon how carefully the copper plate had been cleaned before silvering. The importance of that stage, and the dire consequences of carelessness, were underlined by the reluctance of photographers initially to trust commercially silvered plates. Those who did buy them often elected to give them a brief cleansing wash in dilute sulphuric acid, followed by a second silvering. This was achieved by suspending the plate in a solution of silver chlo-

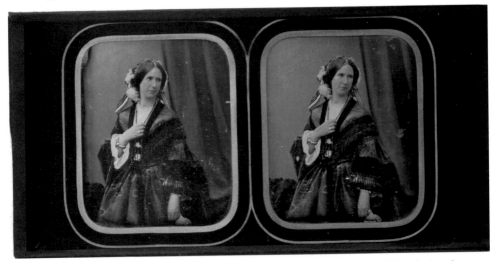

A stereoscopic daguerreotype of an unknown lady by Antoine Claudet, delicately tinted and gilded. This stereo represents a significant investment for the sitter. Claudet's original studio at the Adelaide Gallery off The Strand operated from June 1841 until 1851. He operated from 107 Regent Street, in an area known as the Quadrant, from 1852 until 1868. From this address he produced a wide range of commercial photography. By the time this portrait was made, Claudet enjoyed royal patronage and incorporated Queen Victoria's coat of arms on his labels (see opposite page).

ride dissolved in potassium cyanide. When the daguerreotype plate was suspended in this solution and connected to one terminal of a galvanic battery, the other terminal being connected to a small sheet of silver, a marked thickening of the silver coating was achieved.

Once coated, the silver surface was cleaned, buffed and polished to achieve the highly reflective mirror surface usually associated with the daguerreotype. The polish was achieved in several stages. The first stage in that process involved swabbing the plate with a piece of cotton soaked in a weak solution of nitric acid and then applying a polishing powder made from a decomposed silicious limestone known as 'rottenstone'. A finer form of rottenstone known as 'tripoli' was used in the next polishing stage. Before the final polishing stage, for which rouge, lampblack and a velvet buffing strip were used, the edges of the plate were bent slightly away from the silvered side, to avoid tearing the buffing strip to shreds. A variety of patent devices were marketed in the 1840s and 1850s to apply that slight downward roll to the plate edges.

The buffing action was believed to have a visual impact in the final photograph, so text books suggested that a circular motion be used for initial polishing, but that the final polish be given from side to side – across the length of the plate for a landscape daguerreotype, across the

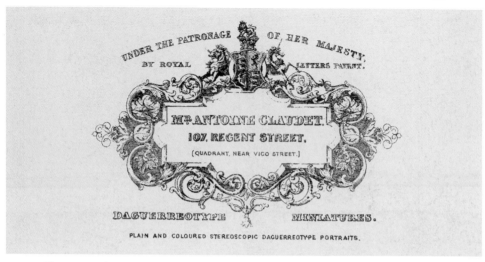

This ornate label formed the reverse of stereoscopic daguerreotypes produced by Antoine Claudet's studio. During the 1840s he took out a number of patents to cover aspects of daguerreotype practice. His 1841 patent number 9193, simply entitled 'Daguerreotypes', offered interchangeable lenses for the daguerreotype camera, an early suggestion for combining the exposure and processing of daguerreotypes within the camera, the use of decorated and scenic backgrounds in the studio, artificial light as an exposing source, and the use of coloured window filters in the 'darkroom' to introduce more light on to the operator's tasks in coating and processing. While that 1841 patent was Claudet's own work, a second patent in 1843, number 9957, dealt with printing from daguerreotype plates and was filed on behalf of 'a foreigner residing abroad'.

Above left: *A double 'fuming box' was introduced with process modifications which were claimed significantly to enhance sensitivity by exposing the plate to a combination of iodine and either bromine or chlorine during the sensitising stage.*
Above centre: *A single 'fuming box' used to expose the plate to iodine vapour.*
Above right: *The buffing wheel offered the busy photographer an alternative to the velvet buffing strip and speeded up the cleaning and polishing operations.*

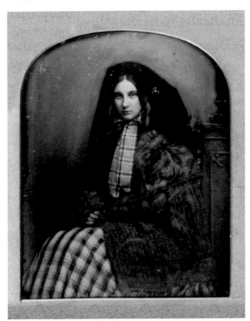

Left: *Plate sizes: this image is described as sixth plate size. Sizes were based on fractions of a Victorian glass plate, which measured 6.5 by 8.5 inches (16.5 by 21.5 cm), as used in windows, and were used to describe all small images, including daguerreotypes, despite the fact that these were not on glass. To keep proportions the same, half plate was a little more than half of the sheet, but quarter plate was a genuine quarter. Other popular sizes were ninth and six-teenth.*

Top right: *Richard Lowe, an American photographer living in England, opened, or rather reopened, a studio in the Promenade, Cheltenham, in 1850. Originally established in 1841 as the Cheltenham Photographic Institution, the studio had had a succession of owners and managers before Lowe took it over. Lowe was a master of the daguerreotype, both in his posing and in his control of light, and by 1856 he had built up a considerable reputation both as a photographer and as a colourist using both the daguerreotype and the collodion positive or ambrotype.*

One day his studio did not open. In early November 1856, one week after Lowe's last advertisement had appeared in the Cheltenham Examiner, the newspaper carried the following report:

'Some excitement was occasioned in the town during the early part of last week, in consequence of the sudden disappearance from Cheltenham of Mr Richard Lowe, a photographic artist, whose rooms in the centre of the Promenade must be known to every visitor to the town. On Thursday, he took his departure by train for Liverpool, en route, it is presumed, for America, the land of his birth. Previous to his final leave-taking, he called upon several tradesmen and made extensive purchases, the latter not hesitating for a moment to supply a man whose credit hitherto had been of the highest character. Messrs. Martin and Baskett, silversmiths; Messrs. Shirer and Sons, drapers; Mr. Samuel, furrier; Mr. Isaacher, jeweller; and Messrs. Newman and Lance, drapers, are among the number of victims, the losses of whom, when combined, amount to a pretty considerable sum. The 'departure' becoming known, a meeting of tradesmen was convened, and a capture decided upon. For this purpose, an immediate telegraphic communication with a detective was commenced, and the detention of the fugitive relied upon, but owing to some mistake, as we hear, in the transmission of a subsequent message, the pursuit was abandoned.'

Lowe was never heard of again in England. The studio reopened shortly afterwards under the management of Mr George Alder, whose occupancy seems to have been very short-lived. By 1857, Charles Pottinger was described as the proprietor in local trade directories.

width for a portrait. Particular care was needed to keep the polishing strip clean, as any abrasion could destroy a considerable amount of work. Most text books recommended that the final buffing took place just before the plate was sensitised, again as a precaution against dust and grease.

Sensitising the silvered plate, in early versions of the process, involved a brief exposure to iodine vapour, but in later faster versions iodine and either bromine or chlorine were used. Some variants proposed iodine followed by both bromine and chlorine, claiming enhanced sensitivity and shorter exposures.

For the sensitising process, pure iodine crystals were scattered in the bottom of a wooden box and covered with cotton wool to disperse the fumes evenly. The plate was then dropped face down on to a frame, and a protective sheath removed to allow the vapours to reach it. The length of exposure to the fumes varied from operator to operator, but it usually continued until the plate had taken on a deep yellow colour. An accelerator stage involved an exposure to a solution of bromine in water until the plate took on a rose-red hue, after which followed a second short exposure to the iodine. After this, the plate, now light-sensitive, was ready for exposure in the camera.

With cameras of French design, exposure was commenced by the removal of a lens cap. For American-design cameras – with a mirror rather than a lens – a hinged flap was lifted out of the optical path. Daguerre's early experimental images required exposures as long as fifteen minutes but by the time commercial studio portraiture was well established exposures had generally been reduced to less than one minute.

Even so, architectural and landscape daguerreotypes faithfully recorded only figures which had either been carefully posed or were seated throughout the exposure. Those who merely passed through the field of view of the camera while the exposure was being made were recorded as no more than a dark blur – or a ghost-like transparent figure, if they paused briefly before continuing on their way!

After exposure, the plate was taken immediately to the darkroom for developing, arguably the most hazardous aspect of the process for the operator. Development was carried out over a bath of heated mercury, the toxic fumes reacting with the exposed silver halides to reveal a direct positive image on the surface of the plate.

The developing box contained a small oil lamp to heat the mercury, and a rack to hold the plate, face down, above the bath. In the United States it evolved into a distinctive metal pyramid, while British and French designs were usually made of wood. Most designs incorporated a viewing window: developing by inspection rather than by timing was the norm and that inspection was usually aided by the light of a candle.

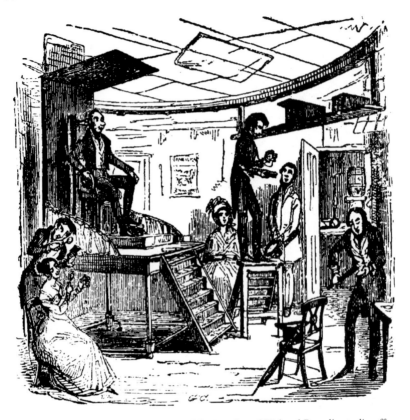

George Cruikshank's famous cartoon of the interior of Richard Beard's studio offers a good insight into the typical design and equipment of the daguerreotype studio and darkroom.

Daylight was the exposing source. Many photographers used a glasshouse, not unlike a large greenhouse, on the roof of a tall building (see John Frederick Timms's business card, page 5). In this illustration, a glass roof provided the illumination. The subject was seated on a movable platform which could always be turned towards the light. To ensure that the camera position was always appropriate, two cameras can be seen on a raised platform running on rails around the studio walls. Additionally calico or cotton blinds could be drawn across the glass roof panels to control light level and direction, and a dark movable screen was suspended over the subject's head to reduce glare from excessive top lighting. In today's studios, the photographer starts with a darkened room and introduces light where it is needed. In the Victorian glasshouse studio, with even lighting from the large expanse of glass, the photographer used screens and blinds to remove light where it was not wanted. The photographer, standing on top of a small flight of steps, seems to be timing an exposure, while his assistant, bottom right, appears to be buffing a daguerreotype plate prior to sensitising. Two satisfied customers, bottom left, are admiring their recently completed daguerreotype portraits. Through the door beneath the camera platform, the darkroom bench can be seen. As optimum plate sensitivity depended upon the sensitising being completed just before exposure, having the darkroom close at hand was considered essential.

Three early daguerreotype portraits, of a mother and her two daughters, probably taken in an American studio, late 1840s. The photographer is unknown. These portraits, set in embossed leather cases lined with pink silk, are typical of the output of the period.

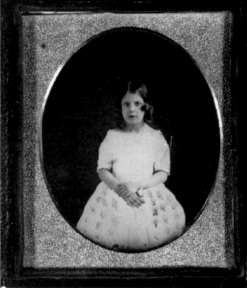

Left: *The exposure times for early daguerreotypes were of considerable length. To ensure that the portrait was not ruined by movement of the subject, head clamps were often used to help the subject sit still for anything from a few seconds up to one or two minutes. The high cost of the daguerreotype, and the status it imparted to its owners, were sufficient to persuade upper and middle class sitters to submit to such indignities. The subject sat with head firmly against the twin arms of the head clamp, trying hard not to blink, thus ensuring the sombre and strained expression common on many Victorian portraits. The solemn image of the Victorians is due in no small measure to the discomfort which was associated with having their portraits taken. Head clamps continued to be used into the 1860s, and many cartes de visite show trace of the clamps and stands behind the subject.*

Below: *'The Transepts of the Great Exhibition, Looking North, Held in London in 1851', engraved by William Lacey, from a 10 by 8 inch (25 by 20 cm) daguerreotype by J. E. Mayall. In the original daguerreotype, which survives in a private collection in America, only three people are evident. Two have clearly been posed to give the engraver a scale reference, and the third is a shadowy ghost-like figure who paused briefly during the long exposure. All the other figures in the engraving come into the category of 'artistic licence'.*

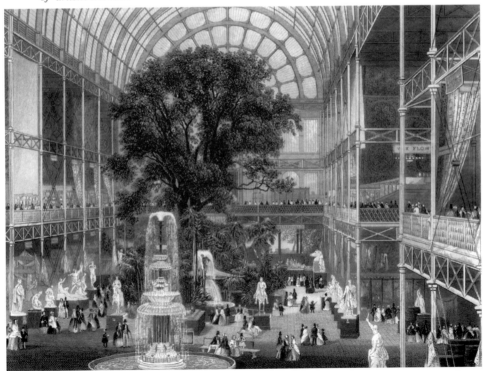

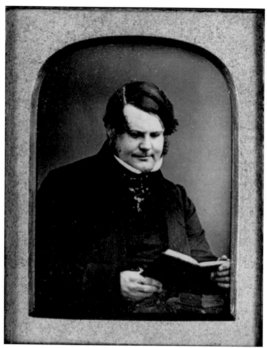

An unidentified clergyman reading a book, perhaps the Bible. Ninth plate daguerreotype by J. E. Mayall, 1853-5. John Edwin Mayall first advertised his studio at the Daguerreotype Institution, 433 The Strand, London, in May 1847. He did not list this studio address in trade directories until the period 1853-5, although it presumably remained open. From 1853 he also advertised a studio at 224 Regent Street, an address at which he remained until at least 1889. In a photographic career which spanned nearly forty years, he became known as one of London's leading photographers, using every new process and style to be introduced. His carte de visite photographs of Queen Victoria and her children, often tinted, and usually bearing the legend 'Mayall Fecit', were found in family albums throughout the British Empire.

While American developing boxes included a Fahrenheit thermometer to measure the temperature of the mercury, most French photographers measured in centigrade. Some British developing boxes merely carried instructions that the mercury should be heated until the dish was almost too hot to touch! Usually, however, 170°F or 77°C was the recommended temperature. Development usually took between ten and twenty minutes and was followed by fixing the image in a solution of potassium thiosulphate (erroneously believed to be 'hyposulphate', thus introducing 'hypo' into the language of photography as an immediately recognisable term for the fixer). A wash in distilled water was followed by toning in gold chloride to improve the permanence of the image. Gentle drying over a spirit lamp, holding the plate at an angle so all the

excess water drained off, left the processed dry image ready for framing or casing to the customer's taste.

Many daguerreotypes were tinted and gilded to achieve a much more natural effect. They were then covered with a brass matte and a cover glass before being sealed in with paper soaked in gum arabic. The airtight seal is the reason why so many of them have survived to be enjoyed today. It is said that the damage done to daguerreotypes by the

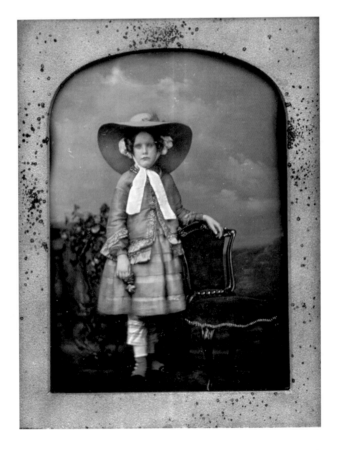

Quarter plate daguerreotype portrait of a young girl in her Sunday best, photographed by William Kilburn and reproduced here at actual size. Despite the fact that the little girl has blinked during the long exposure, this portrait was still a treasured family possession. A further example of Kilburn's work can be seen on page 89.

heavily polluted air of the second half of the twentieth century has been greater than that caused by the complete century before. If that is the case, then the future for these wonderful images is not very secure at all.

When Mr Edwards opened his studio in Glasgow in late 1842, the advertised price for a daguerreotype produced in his studio was one guinea, complete with 'handsome miniature case or frame'. One guinea represented perhaps two weeks wages for a skilled man, placing the ownership of a daguerreotype portrait well beyond the means of all but the very wealthy. Well over a decade later, John Frederick Timms was offering 'Timms's Shilling Portraits' at his Holborn studio in London, on 'paper, glass, iron, silver plate, or leather'– the silver plate being the daguerreotype. At the same time that Mr Timms was offering daguerreotypes at one shilling each, they were being offered in the United States at 25 cents, a comparable sum of money.

Clearly, the subjects who sat for Mr Edwards's camera in 1842 and 1843 were from an entirely different financial background to those who later paid one shilling to John Timms. Photography had in that decade and a half reached a much wider cross-section of Victorian society.

J. White's 25 cent ambrotypes and daguerreotypes: a trade label from the mid 1850s, used to back a ninth plate daguerreotype portrait in a plastic union case. Like White, many British photographers advertised their ability to fit daguerreotypes into brooches, lockets and the like. In newspaper reports of the opening of the Edwards studio in Dumfries in March 1843 it was noted that he was 'producing miniatures within the diameter of a ring or sleeve button, yet as distinct in their details as the camera can make them'.

The allusion to the miniature painting in the marketing of early photography was an opportune and appropriate one, for the market for the new medium included those who had perhaps aspired to, but been unable to afford, a painted miniature. The use of cases to house the new portraits further echoed that class-specific tradition and added to photography's allure.

The process was hugely successful in its time, and it remained in common usage for much longer than many might assume. There were still many studios producing daguerreotypes in Britain into the early 1860s, two decades after the first introduction of the process.

The daguerreotype may have been difficult to duplicate, and often challenging to view, but it helped establish a value for photography in general, and for the photographic portrait in particular.

An unidentified gentleman: ninth plate tinted and gilded daguerreotype by Beard & Foard, taken in Manchester about 1854-5. James T. Foard is first mentioned at the Liverpool studio operated by Richard Beard Junior. Beard listed the studio under his own name from 1851, and Foard was brought in as a partner at some time prior to 1854. In the 1855 trade directories for Liverpool the studio at 34 Church Street is styled 'Beard & Foard', as is a second studio in St Ann's Square, Manchester.

Foard was a leading light in the Manchester Photographic Society from its foundation in the 1850s, a friend of the great photographer Roger Fenton, and a highly skilled photographer himself, using sophisticated poses and subtle lighting in his portraiture. The Manchester studio was taken over in 1858 by Alfred Brothers, who operated there until the 1890s and played a major role in the history of photography in Manchester.

The collodion photographer and his studio

Photography as we know it today dates from the introduction of the first negative process – the Photogenic Drawing process invented by William Henry Fox Talbot – from which positive prints could be made. From that innovation have grown today's sophisticated systems.

Improving upon photogenic drawing, by reducing exposures and introducing the concept of 'development', Talbot evolved his calotype process in 1840 and patented it in 1841.

The calotype and the daguerreotype were introduced at about the

Melrose Abbey from the south, a calotype by William Henry Fox Talbot. This image was used as one of the illustrations in Talbot's pioneering book 'Sun Pictures in Scotland'. The calotype was the first process to allow the easy duplication of images, setting the pattern for today's negative/positive processes.

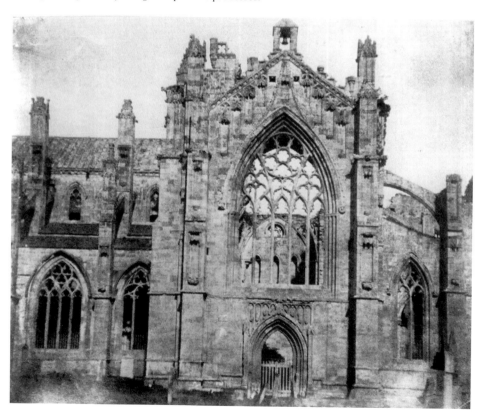

same time, and a degree of competitive rivalry existed between their inventors and their supporters. The detailed but unique daguerreotype was ideally suited to the production of intimate portrait miniatures, while the calotype negative, from which salted paper prints could be made with relative ease, had a number of obvious applications where multiple images were required. For example, Henry Fox Talbot was quick to demonstrate the value of photographs to illustrate books, with the publication of the world's first photographic 'part-work', *The Pencil of Nature*, in 1843, and *Sun Pictures in Scotland* in the following year.

Despite early enthusiasm for the negative/positive process, there were early signs that the calotype had its limitations. The paper negative proved slow to print, and the texture of the paper itself gave a fibrous and sometimes granular appearance to prints.

In the late 1840s Claude Felix Abel Niépce de St Victor proposed glass as an ideal base for the negative material, coating the glass with the light-sensitive chemicals suspended in albumen (egg-white). The material had a relatively low sensitivity to light, but by replacing the paper with a clear base like glass both sharpness and the ability to reproduce fine detail in the print were significantly improved.

Gustave le Gray's Waxed Paper process of 1850 coated the light-sensitive chemicals on to sheets of pre-waxed paper, eliminating the paper texture and improving the keeping qualities of the material. With this process, for the first time, photographers were able to prepare their materials some weeks before using them and process them some time after exposure.

The process which signalled rapid growth in Victorian photography was the wet collodion process, introduced by Frederick Scott Archer in 1850, employing an idea which had been proposed by Gustave le Gray and others in the late 1840s.

Collodion was a mixture of guncotton and ether, which had been developed originally as a means of dressing wounds. The mixture dried to form a clear film, and Archer had originally proposed to use the collodion film itself as an alternative to Talbot's paper or le Gray's waxed paper. However, his experiments demonstrated that the sensitivity of the collodion emulsion was much lower when dry than when wet. Despite the obvious problems associated with coating and then exposing plates while still wet and sticky, the wet collodion process was the means by which some of the most important photography of the mid Victorian period was made.

Wet collodion was, from its inception, free of patents – except for a few attempts by Fox Talbot and others to claim rights over it, by virtue of the fact that a negative was produced, the idea of the negative having

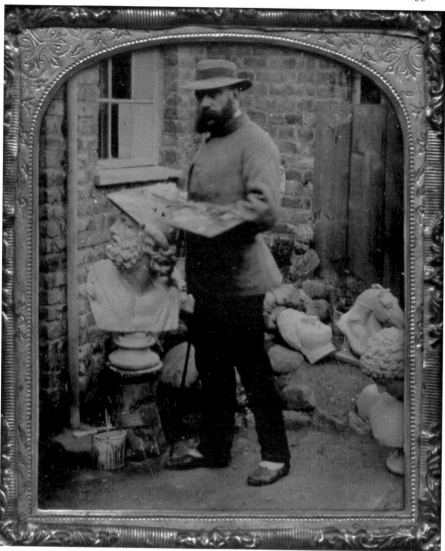

Sixth plate ambrotype, taken in the backyard of an artist, art restorer or dealer in art objects by an unknown photographer, c.1865. The gentleman is holding an artist's palette and brush, and a tin of white paint, with brushes, is seen at the bottom left of the picture. The objects in the yard appear to be plaster casts of busts in the British Museum, and the large bust to the left of the artist is standing on a wooden plinth which seems to bear the royal coat of arms. Behind the artist, against the back wall, lies the badly damaged bust of a (Roman?) child, perhaps awaiting repainting or repair. This sort of outdoor occupational ambrotype is relatively uncommon but offers a valuable glimpse of Victorian working life.

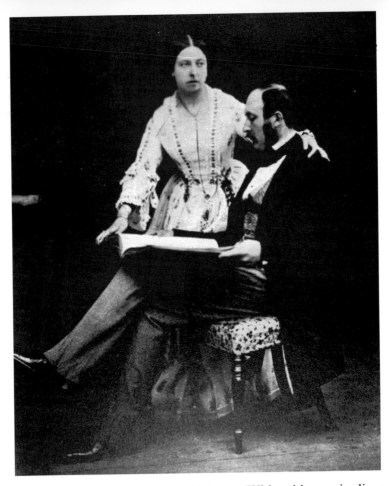

been contained within Talbot's 1841 patent. With neither major licence costs nor restrictions, wet collodion's combination of very high image quality and higher sensitivity made it attractive to both amateur and professional photographers, despite the obvious drawbacks of the coating and processing procedures.

If there is a typical distinction between amateur photographers and professional photographers, it is that the former – today still, as was the case in Victorian times – produce many negatives and relatively few prints, while the latter typically produce fewer negatives and many prints. For example, Dr Thomas Keith, the Scottish Victorian amateur, is today represented by a very high percentage of all the Waxed Paper negatives he ever made, but by relatively few contemporary salt prints. Roger Fenton, the consummate professional, is today remembered through a huge body of prints, and only a very few of his wet collodion negatives. Those few negatives have survived only because they were never used 'commercially', being the plates from private portraiture

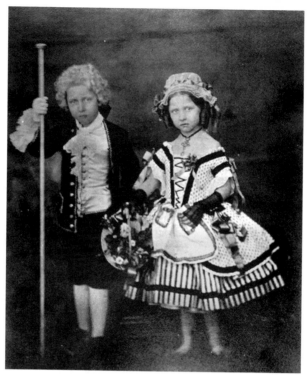

Opposite page: *Queen Victoria and Prince Albert.*
Above: *Princess Louise and Princess Helena in costume.*
Both these images were made at Buckingham Palace by Roger Fenton in March 1853.
In addition to photographing the Queen and the Prince, singly, together and with their children, Fenton also taught them the rudiments of photography, advising not only on the equipment and techniques of the wet collodion process, but also helping them establish and equip a darkroom at the palace. In addition to both formal and informal photographs of the royal couple and their children, Roger Fenton also staged elaborate 'tableaux vivants', using the royal children as willing cast members, acting out scenes from history and mythology.

The negatives of many of these rare and early glimpses of the Royal Family 'off duty' have only recently been rediscovered in the cellars of Buckingham Palace and placed in the Royal Archives at Windsor. Clearly, Queen Victoria recognised as early as 1853 the risks of letting photographs of royalty fall into the wrong hands.

That they present such a surprisingly casual view of royalty so early in the lifetime of photography is a testament to Fenton's skill in posing his subjects. Exposure times must have been quite considerable, yet these pictures have an immediacy which denies the lengths to which both photographer and subjects must have gone to present such a lively image.

In 1901, long after Roger Fenton's death, his brother-in-law, Vernon Armitage, was sufficiently impressed by these early portrait studies to see them as an ideal coronation gift for the new king, Edward VII, himself the childhood subject of many of Fenton's tableaux. Armitage was no great photographer but, in the absence of the original negatives, used gelatine dry plates, somewhat crudely, to copy Fenton's early salt print masterpieces. Small silver bromide prints of his efforts, mounted in an album adorned with the royal crest, were presented to the new king, and five identical albums were distributed amongst the family. Contained within the albums are copies of some images which had been believed lost. For his efforts, Armitage received a formal letter of thanks from one of the new king's aides, and a photograph of Edward VII, which he mounted at the end of the album of Fenton copies.

sessions taken at Buckingham Palace for Queen Victoria and Prince Albert.

With those different requirements in mind, the alacrity with which the profession embraced wet collodion is understandable: speed of printing was essential if sales were to be increased. For the amateur, the decision is less easily understood. Wet collodion was the most difficult and cumbersome of all the Victorian processes to manipulate.

However, wet collodion's domination of early photography was by no means immediate. Indeed, the selection of Roger Fenton in 1854 for the photographic expedition to the war in the Crimea, over three years after the collodion process was first announced, was primarily by virtue of his considerable familiarity with the process.

The daguerreotype's dominance was only partially dented by the collodion positive or ambrotype, and both the plain paper and waxed paper processes were still in their ascendancy as wet collodion was introduced. Those many processes existed side by side for much of the decade.

Collodion did, however, rapidly gain supremacy in the growing number of professional studios, where the easy and rapid production of long

Opposite page and above: *Two ambrotype portraits of a regimental sergeant major in the undress uniform of the 17th Light Dragoon (Lancers), 1850s.*
These two ambrotypes (the image on the opposite page is sixth plate, the image above is quarter plate) appear to have been taken within days of each other, using the collodion positive or 'ambrotype' process, which was promoted as a successor to the more expensive daguerreotype. Neither photographer has identified himself, despite the obvious quality of both images, and these two images represent two quite different approaches to using the process. The ambrotype was, in essence, a thin wet collodion negative, sometimes bleached, but always backed with either black paper or black shellac to reveal the positive image. The quarter plate image, once carefully tinted and gilded, is presented emulsion side up, and therefore with the image laterally reversed. Tunic buttons are on the wrong jacket face, and medals are apparently worn on the wrong breast. Many mid-Victorian images are reversed in this way: many portraits show wedding rings on the wrong hands, for example. The tinting and gilding which adorned many images was more easily applied to the emulsion side, so the emulsion side had to be uppermost and, unless a reversing prism was used on the camera, this inevitably meant incorrect reading of the image. A cover glass on top of the chased brass matte was used to protect the emulsion. The smaller sixth plate image has been corrected by the simple expedient of presenting the glass plate emulsion-side down within its leather case – the emulsion has been sealed beneath a layer of black shellac lacquer – so that we are viewing the portrait through the back of the plate.

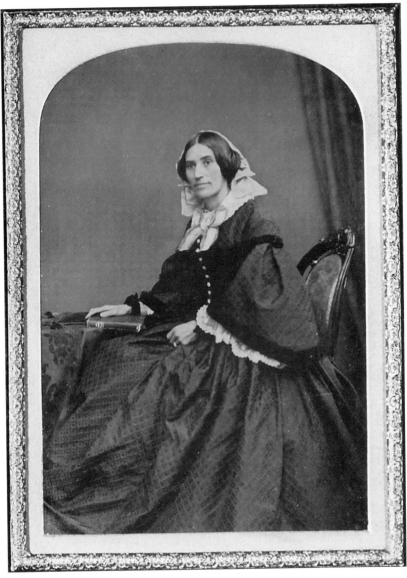

Half plate ambrotype, tinted and gilded, by G. & D. Hay of Edinburgh, c.1860. G. & D. Hay, whose studio was at 68 Princes Street, described themselves as 'Photographists'. The image has been elaborately coloured. In addition to the expected facial tinting, the lady's bonnet and bow are picked out in pale blue, pink and gold, her book has a gilt spine, and the elaborate pattern on the chair back has been tinted in a variety of colours. The image is in a burgundy leather case with the photographer's gilt stamp on the back.

print runs was required. In that field collodion negatives and Blanquart-Evrard's albumen printing paper had no equal.

As the demands for commercial photography increased, so did the sophistication of the facilities used to produce it. With collodion, the daylight studio, introduced with the daguerreotype, was developed and, by the 1870s, augmented by electric light. While printing remained essentially an outdoor activity for many years, the darkroom where the plates were coated and processed became a laboratory in which some sophisticated chemistry was carried out.

In 1864 Professor John Towler MD introduced readers of his text-book *The Silver Sunbeam* to the particular design requirements of studio, workroom and darkroom intended for users of the wet collodion process with the words: '*The Dark-Chamber and the ordinary work-room may be constructed on the northern side of the glass-house, the window of one being glazed with an orange-yellow coloured glass, in order to absorb the actinic rays, and the other with common crown-glass. On the outside of the side windows, small platforms are formed for the reception of the printing frames......*'

It is interesting to observe the changing importance of the space used for preparing materials as sensitivity increases. With collodion's short exposure, and the need to prepare and use the plates all within a short period – before the collodion could dry, appropriate and adjacent facilities became essential. Towler offered valuable advice to aspiring amateurs and professionals who might be considering custom-built facilities: '*The chamber intended for all operations of sensitising, commonly called the Dark-Room, ought to lie contiguous to and open into the common operating or work-room of the photographer; and both these rooms ought to open directly into the glass-house A single pane of orange-yellow coloured glass is all that is needed... ...This mode of admitting light permits the progress of the development to be distinctly watched much more effectively than by reflected light.*'

William Lake Price, an influential photographer as well as a leading writer on the subject, confirmed the importance of a well-designed darkroom in his 1868 edition of the *Manual of Photographic Manipulation*, when he wrote: '*small and inconvenient dens may be made to do duty on occasion, but if it be possible to obtain a certain space, say sixteen feet by twelve, for this purpose, it will be well bestowed, both in the increased convenience for the production of the negatives, and for the health of the operator, by the superior ventilation it affords.*'

Given that the ether, used to dissolve the guncotton when making the collodion itself, produced one of the most powerful fumes imaginable, the good ventilation suggested was a sound idea. A 16 foot by 12 foot (4.8 by 3.7 metre) darkroom would be a luxury and Price's advice as to

its contents was well made: *'Let the darkroom contain only those things which legitimately belong to it; let the shelves &c., be washed frequently and kept free from dust, the sinks in the cleanest condition, and the floor covered with oilcloth, as being the material with the most unbroken surface and most easily purified from dirt.'*

He also suggested a fireplace for warmth in winter, which could also be used for the drying of excited papers. The ventilator had to be light-trapped to ensure that no daylight entered via its flue. All the other requirements were to ensure cleanliness, and to avoid risk of chemical contamination: *'Two sinks lined with gutta-percha, with waste-pipes of the same material, should be fitted entirely separated from each other; one for developing the picture, the other for standing the negatives in to steep in water, which should be laid on with several taps to both sinks. Gas, likewise, should be fitted along the sinks with deep yellow glass chimneys to the burners. Shelves for bottles, and a well-made close-fitting cupboard for chemicals, are wanted; at the same time it is especially advised not to make the shelves of the dark-room receptacles for all the nameless rubbish apt to accumulate in such a locality, and thereby establish dust traps to the certain deterioration or destruction of future pictures.'*

Perhaps more than any other process, wet collodion, because of the sticky nature of the material as it dried, attracted dust. Many fine images were irretrievably ruined by dirt adhering to the collodion.

For the same reason photographers were advised against using curtains to keep light from entering around the frames of doors: all fabrics collected and scattered too much dust. Instead strips of leather pinned around the door were the recommended means of light-trapping.

A number of proposed designs for both amateur and professional darkrooms were published in the photographic press of the day. Thanks to meticulous records, a great deal is known about some of the most significant darkroom developments of the period, and the facilities constructed at the British Museum are a significant example.

The British Museum's official photographer, appointed in 1853, was none other than Roger Fenton, who would go on to achieve fame as the photographer of the Crimean War. It was not Fenton, however, but another eminent Victorian photographer, Philip Delamotte, who was consulted by the museum staff on the design, construction and equipment of the 'photographic room'.

The facilities the British Museum developed comprised a glasshouse studio and adjacent darkroom, constructed on the roof, although many of the pictures Fenton subsequently produced were taken out in the open air on the 'leads', a flat part of the roof itself where the light was better.

An Assyrian tablet, photographed by Roger Fenton c.1853. Fenton's lengthy involvement with the British Museum led to the production of an enormous body of work and, in no small part, to the establishment of the photograph as an alternative means of accessing a museum's collection. The British Museum records are extensive and contain a detailed account of the development of the photographic facility which Fenton used to produce photographs of some of the museum's finest treasures. Although not involved at the outset, he was central to the development of the studio and darkroom, and also to the establishment of a similar facility for Queen Victoria and Prince Albert, both of whom he introduced to the 'black art' of photography.

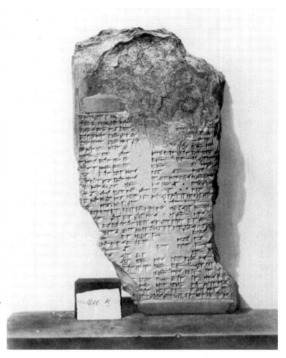

Alongside a 20 by 10 foot (6.1 by 3.0 metre) studio, which had a ceiling height of only 7 feet 6 inches (2.3 metres), was a long narrow darkroom, 20 feet (6.1 metres) long and only 4 feet 6 inches (1.4 metres) wide, 'glazed with yellow glass, having also yellow calico blinds', which was used for processing. A separate movable wooden 'dark closet' on castors and covered with canvas, measuring 6 by 5 feet (1.8 by 1.5 metres), may have been the place where the plates were coated with the sticky collodion mixture and associated light-sensitive chemistry. The whole construction was to be erected 'in as slight and inexpensive a manner as possible' and eventually cost £300 – which in no way could be considered inexpensive in 1853.

This facility was only for the coating, exposure and processing of plates. Roger Fenton later acknowledged in a letter to the Trustees of the British Museum that to meet demands for multiple prints from his negatives he had built his own printing establishment and employed staff to work there.

For the average photographer, without the luxury of the museum's large darkroom, the risks of using the process in often cramped and airless conditions must have seemed to offer a limited choice: if the

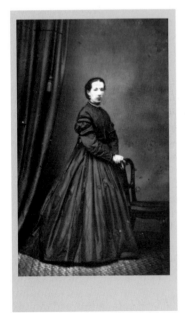

Above left: _Wet collodion portrait negative, 1860s, taken by John Longshaw of Warrington. The wet plate photographer had to perform every stage of the preparation of the plate himself, including coating the sticky collodion emulsion on to the carefully cleaned glass. To achieve an even coating, the photographer held one corner of the plate between the thumb and first finger of the left hand, while a small pool of the iodised collodion was poured on to the middle of the glass. The plate was then deftly tilted in every direction to drive the collodion to the edges. On some occasions, the collodion did not get right to the edges before it became too tacky to flow. On every plate, the mixture did not reach the corner beneath the photographer's thumb. The photographer's left thumb print can clearly be seen in the bottom left corner of the quarter plate negative, and the opposite corner of the contact print_ (above right).

Left: _When using single shot quarter plate cameras to take carte de visite portraits, quite a large proportion of the albumen contact print was discarded when trimmed down to the typical 55 mm by 85 mm print area which was mounted on to the carte. At such a crop, all evidence of uneven coating was removed. It was relatively unusual to use single shot cameras in this way – larger studios took four individual portraits on a whole plate negative._

fumes did not get them, the explosion might!

In order to maximise the sensitivity of the plate, as many of the preparation stages as possible had to be completed just before the plate was exposed in the camera. This meant that most portrait photography was a two-man operation. While the photographer posed the sitter and arranged the clamps and supports necessary to sustain the pose during the long exposure, the photographer's assistant would be in the dark-room preparing the plate. Photographers working on their own must have subjected their sitters to a prolonged and uncomfortable wait in the studio chair while these essential stages were completed behind closed doors.

With wet collodion the number of studios proliferated, and there was a significant quality difference between the best and the worst. In his *London Labour and London Poor* published in several editions be-tween 1851 and 1864, Henry Mayhew, the former editor of *Punch*, devoted a chapter to the practices of the less scrupulous photographers. In addition to detailing such practices as selling people portraits of someone else, on the assumption that, with few mirrors around, there were many people who did not know what they looked like, Mayhew's source, who took both ambrotype and tintype portraits and was paid one guinea for his story, had some interesting observations to make:

'Sunday is the best day for the shilling portrait; in fact the majority is shilling ones, because then, you see, people have got their wages, and don't mind spending... The largest amount I've taken in Southwark on a Sunday is 80 – over £4 worth... It's a very neat little picture our six-penny one is; with a little brass rim round them, and a neat metal inside, and a front glass, so how can that pay if you do the legitimate business? The glass will cost you 2d a dozen – this small size – and you give two with every picture; then the chemicals will cost quite a half-penny, and varnish and frame, and fittings, about 2d. We reckon 3d out of each portrait. And then you see there's house-rent, and a man at the door, and a boy at the table, and the operator, all to pay their wages out of this 6d; so you may guess where the profit is...'

Presumably this photographer was working with ninth plate images supplied in a simple paper-covered wooden frame. The two glasses he refers to are the actual image glass, on which the portrait was taken, and the protective cover glass. Few photographers went to such lengths for cheap framed portraits, using just the image glass, backed with black lacquer, and framed glass uppermost.

He went on to refer to the sheer number of photographers who were seeking to extract a living from this new market, and what the going rate was for a camera operator:

'I have been told that there are near upon 250 houses in London now

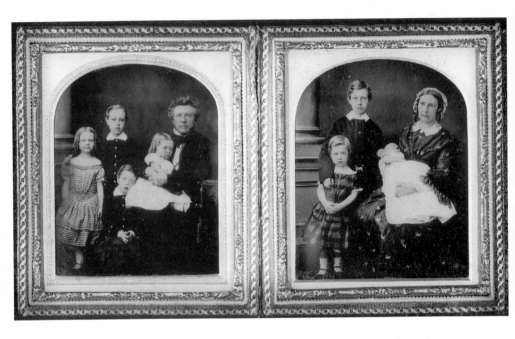

Two sixth plate cased ambrotype portraits (photographer unknown). The ambrotype, like the daguerreotype before it, produced a unique image. If multiple copies were required, multiple plates had to be exposed. At least two ambrotypes of each grouping were made at this sitting, showing the members of the Patten family. John Patten, an Edinburgh advocate (barrister), was photographed with his wife and children in 1859.

getting a livelihood taking sixpenny portraits. There's ninety of 'em I'm personally acquainted with, and one man I know has ten different shops of his own. There's eight in the Whitechapel Road alone, from Butcher Row to the Mile-end turnpike. Bless you, yes! They all make a good living at it. Why, I could go tomorrow and they would be glad to employ me at £2 a week – indeed they have told me so.

If we had begun earlier this summer, we could, only with our little affair, have made from £8 to £10 a week, and about one-third of that is expenses. You see, I operate myself, and that cuts out £2 a week.'

The ambrotype portrait probably represented less than one per cent of the output of wet collodion photographers. The vast majority of wet collodion exposures were printed as *carte de visite* prints, and most of the remainder were landscape and architectural view prints to satisfy a growing tourist market.

Whereas the wet collodion plate on which ambrotype exposures were

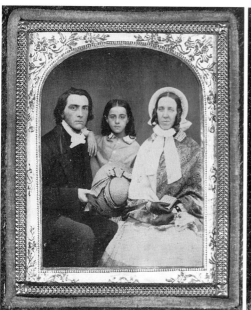
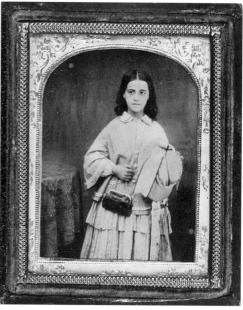

Two ninth plate cased ambrotype portraits made by Duchauffour and McIntyre at their studio in Whitefield Place, off Leith Walk, Edinburgh. Like many photographers, Duchauffour and McIntyre bought ready-made cases and had their gilt stamp applied. The cases for these two portraits have had their name and address added carefully over the central design on an ornate embossed geometric motif.

made was the end product, that is the plate which finally finished up in the case or the wall frame, the wet collodion negative was merely the intermediate stage to the production of a small or large number of prints. But printing was a very different occupation to what it is today. Even its location was different.

If Victorian photographers were to visit today's darkrooms, there would be very little they would recognise. The norm in the early days of photography was the contact print: if a large print was needed, a large negative was required. There was no alternative unless quality was to be compromised.

In the early days the darkroom was the place where the negative materials were coated and prepared. Printing was done outdoors by the light of the sun, using the printing frame and the enlarging camera. The idea of the darkroom as the centre of printing activity, where a small piece of film 24 mm by 36 mm could be enlarged twenty or more times,

would be met with total disbelief.

When Fox Talbot first introduced the calotype, the paper produced for the earlier Photogenic Drawing process became the basic printing paper – the 'salt print' which played such a pivotal role in early paper photography. It was a very simple material to prepare, and, if made and used carefully, produced prints of immense quality and beauty. Salt prints made by Talbot, Roger Fenton, Thomas Keith and others have produced some remarkable imagery.

In his book *Theory and Practice of the Photographic Art* (1856), Roger Fenton's assistant William Sparling wrote of the preparation of 'photogenic paper' for the production of prints:

'Mr. Talbot recommends photogenic paper prepared as follows:

Having dissolved 25 grains of common salt in one ounce of distilled water, dip the paper selected and cut to a proper size into this liquid, leaf by leaf, leaving it there to soak for a short time, and place it between leaves of clean blotting paper to dry; dissolve afterwards 90 grains of crystallized nitrate of silver in an ounce of distilled water, wash the paper on the seen silver side with a soft pencil charged with this liquid, dry it a little, and pass another coating of the liquid over it, dry in thoroughly, suspending it for that purpose by one of its corners.'

Looking at Sparling's instructions without any other information to go on, the reader might wonder how he was supposed to apply the silver nitrate with the aid of a soft pencil. Sparling may have been a good photographer and photographic chemist, but he was clearly not an accomplished proofreader. However, in Rudolph Ackermann's 1839 instruction leaflet for Ackermann's Photogenic Drawing Apparatus, a clearer instruction is forthcoming:

'The paper is now to be pinned down, by two of its corners on a drawing board, by means of two common pins, and one side washed or wetted with the Photogenic Fluid [silver nitrate], using the brush prepared for that purpose, and taking as much care to distribute it equally as if you were laying in a sky in a water-colour drawing.'

It was that combination of the calotype negative process and the salted paper for printing which the Scottish masters David Octavius Hill and Robert Adamson used to produce the most important body of early photographic portraiture in the early 1840s.

The salt print survived well beyond the calotype era, being used by Roger Fenton for printing his important Russian images from 1852 and for many of his Crimean images in 1855. It was superseded by albumen paper, which gave a sharper image, largely because the image was carried within a surface-coated 'emulsion' rather than within the paper thickness as with the salt print. Albumen printing paper soon swept all before it but, in the opinion of the present author, never quite achieved

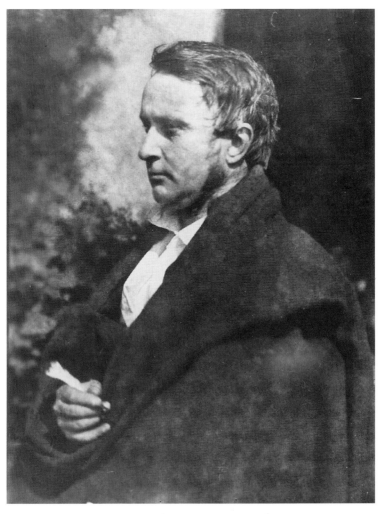

James Ballantyne, author and stained glass artist, 1844-5. Salt prints from the calotype negative made by the Scottish masters David Octavius Hill and Robert Adamson still survive in excellent condition. Hill and Adamson were masters of the calotype process. Although they worked in Scotland, and therefore outside the patent jurisdiction of Henry Fox Talbot, the inventor was happy to exchange information and images with them. From their studio at Rock Cliff on Calton Hill, Edinburgh, the two men produced a series of portraits of the leading figures of mid-Victorian Scottish art and society, as well as the individual studies for Hill's great oil painting of the clergy who left the Church of Scotland to form the Free Church. They also produced the definitive study of the fisher folk of the Firth of Forth, an early success at documentary photography, and a major historical document today.

the magical quality of a fine salt print.

The basis of all albumen printing was egg-white, and such was the demand for albumen that factory farming of hens was introduced in the late 1850s to meet the growing demand. According to the *Photographic Journal* in 1862, one London paper manufacturer alone was using in excess of half a million eggs a year, and these were the days of many small manufacturers rather than a few large ones.

Luckily, egg yolks were also in demand, being used extensively in the leather trade as well as in confectionery. As demand for albumen as a binding medium in photography grew, the availability of cheap egg yolks outgrew the demand, and millions of yolks a year were just dumped. For those photographers who used albumen either to make their own waxed paper negative materials or their own printing papers, a recipe book using only egg yolks was available!

Albumenised paper, coated with a layer of albumen impregnated with salt but not yet sensitised, was one of the earliest photographic materials

Pulteney Harbour, Wick, in the far north of Scotland: albumen print from wet collodion negative. When this image was taken in the 1860s by local photographer Alexander Johnson, Wick was the centre of a huge herring fishing industry. His studio, which lasted through four generations and well over a century of photography, produced a huge archive of social and documentary photography which chronicled the history and people of north-east Scotland. Initially from a glasshouse he had built himself in his back garden, Alexander Johnson exploited almost every technique and format of early photography.

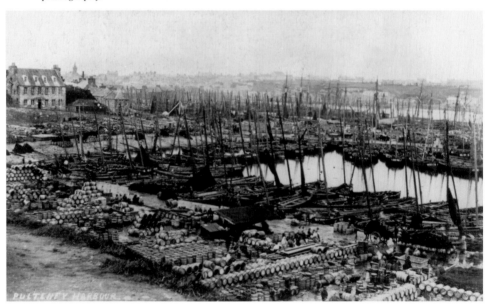

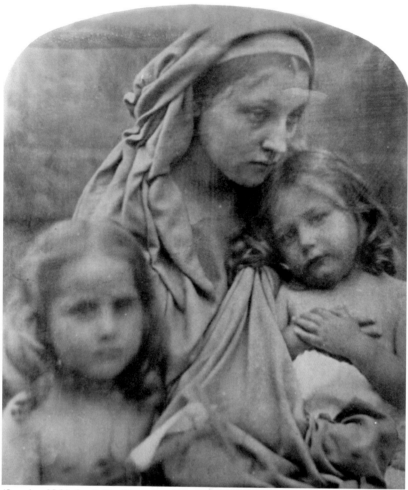

'Love' c.1864, by Julia Margaret Cameron, perhaps the most famous of Victorian portrait photographers. Mrs Cameron's subjects included the leading figures of art, science and literature. Her portraits of Sir John Herschel, Alfred, Lord Tennyson, and Thomas Carlyle amongst others are unrivalled in their perception. Mrs Cameron took up photography late in life and never exhibited any real understanding of the process she used. Yet her ability both to persuade often unwilling subjects to pose for her and then to look deep into their characters rightly earned her a reputation as the finest portraitist of her time. 'Love' was a product of one of her most fruitful themes and was taken at the same time as such similar studies as 'Goodness', 'Faith' and many others. The subjects are Mary Hillier, Lizzie Koewen and Alice Koewen, who posed for a series of Madonna and Child portraits. Mary Hillier was one of the maids at Mrs Cameron's home at Freshwater on the Isle of Wight and was probably her favourite model. So total was Mrs Cameron's obsession with photography that posing for her took precedence over household duties.

to be available commercially. However, as the paper had a short shelf life, the production of ready sensitised paper was not practical.

Just before use, the paper was sensitised with silver nitrate, which reacted with the sodium chloride (salt) to produce the light-sensitive silver chloride. It was dried, and worked best if used within a few hours.

After an exposure in contact with the negative which might vary from

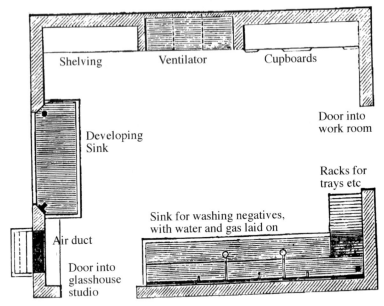

Contemporary books and magazines offered their readers advice on darkroom design for the wet collodion process. This 1864 design was suitable for either a professional or a busy amateur. The design included gas lighting over the sink, with the burners inside tall glass chimneys of yellow glass to create the required safelight colour, and was one of the earliest to suggest safelighting.

minutes to hours, depending upon the density of the negative, the sensitivity of the paper and the brightness of the daylight, a reddish-brown image was produced. This was then fixed, washed and dried.

The permanence of the print and its colour were both greatly improved if the print was toned with gold chloride, giving the rich purple-brown which we associate with fine albumen prints today. The heavy sulphur content of Victorian air, unavoidable given the widespread use of coal fires, caused the whites of untoned albumen prints to go yellow within a very short time. Gold toning helped to reduce the effect of this chemical pollution.

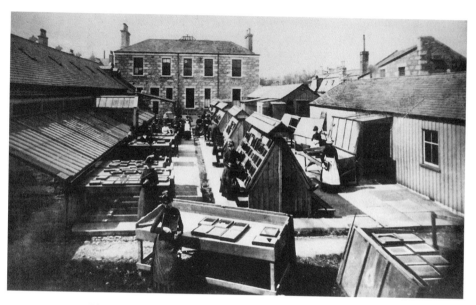

The printing works of George Washington Wilson at Aberdeen.

Printing works were often large open-air sites with row upon row of racks of contact frames tilted towards the sky. Only a few illustrations of these establishments survive. Talbot's printing works in Reading features in an early panoramic calotype, and the Aberdeen factory where the majority of George Washington Wilson's enormous output was printed (illustrated above) features in a small number of photographs.

While negatives were usually printed by contact, enlargements were possible, as the backs of many *cartes de visite* attest.

The concept of the enlarger, powered by sunlight, was one of the many important contributions to photography made by Henry Fox Talbot. He registered a patent for a solar enlarger in the 1840s, although because of the long exposure required a high quality mirror reflector was necessary to direct the sunlight through the enlarger, and it had to be turned frequently over an hour or two (depending on the brightness of the sunlight) before the print was fully exposed.

The majority of albumen printing was carried out without the aid of a developer, leaving the negative and paper in contact in sunlight until the image was produced by the action of light alone.

Where development was used – and salt prints as well as albumen prints could be developed – it was often done as a means of controlling print colour rather than just saving exposure time. For enlargements, however, the developed print was the norm, reducing the exposure time

E MAUNOURY
71 Calle del Palacio LIMA

The great matador Sara: a carte de visite by Felix Tournachon, who traded under the name of 'Nadar', 1860s. Cartes like this were sold by photographers throughout Europe and the United States and as keenly bought by collectors then as they are today.

Prince Arthur, Duke of Connaught, by J. E. Mayall, photographed on 1st March 1862.
Mayall was one of very few carte de visite photographers to date his work. The legend
'Mayall Fecit' and the date can be seen to the right of the young prince's legs.

General Tom Thumb and Wife, Commodore Nutt and Miss Minnie Warren. in the indentical costumes worn before Her Majesty Queen Victoria, at Windsor Castle, June 24. 1865

Tom Thumb, Lavinia Warren, Commodore Nutt and Minnie Warren: one of a series of carte de visite group portraits photographed by the Matthew Brady studio in 1864 and distributed worldwide by E. & H. T. Anthony & Company of 591 Broadway, New York.

from hours to minutes. The developer was usually gallic acid, or alternatively gallo-nitrate of silver.

Because of the low quality optics – big lenses with big apertures to maximise light – and the problems of achieving even illumination which were posed by the variability of the light and the need to maintain the alignment of the mirror, architectural and landscape photographers never used enlarging cameras, as the solar enlargers were known. Even the portraitists tried to dissuade their customers from having *carte de visite* and cabinet negatives enlarged, unless they were going to be painted over. The definition was low, the contrast even lower, and the potential profit hardly worth the time involved.

A solar camera suitable for enlarging a cabinet image was available from as early as the late 1850s and cost £13, a great deal of money at the time, when compared to a cost of £5 for a quarter-plate camera for the collodion process. William Sparling's *Theory and Practice of the Photographic Art* tells us how the instrument worked:
'If a negative portrait of a sitter be placed in the camera slide, and the

Above left: *The back of a carte de visite from A. & G. Taylor, 1860s, advertising their royal patronage as well as the range of services offered in their twenty studios.*

Above right: *James Millard, whose studio was opposite the Market Hall in Wigan, used his carte backs as advertising space for his current price list. Like those of many studios, his cards were produced by Marion of Paris.*

Right: *Portrait in a brooch. The reverse side of the brooch contains a lock of hair. This may be a reminder of a loved one but is more likely to be a mourning brooch. The image is a ninth plate ambrotype, but many studios also offered, as a cheaper service, albumen prints, plain or coloured, from carte de visite negatives reduced to fit in lockets, brooches, buttons and chokers.*

instrument being carried into a dark room, a hole cut in the window shutter so as to admit light through the negative, the luminous rays, after refraction by the lens, will form an image of the exact size of life upon a white screen placed in the position originally occupied by the sitter. These two planes in fact, that of the object and of the image, are strictly conjugate foci, and, as regards the result, it is immaterial from which of the two, anterior or posterior, the rays of light proceed.'

A typical exposure time, as reported in *Photographic Notes* in 1859, to create a life-size portrait from a cabinet negative was around three quarters of an hour. Many studios offered large painted portraits from *carte de visite* portraits, and it was as an intermediary stage in the production of these 'oils' that the solar enlarger was most frequently used.

Reduction in size was much more successful: making smaller prints from a negative, for lockets and brooches and so on, could be achieved with much shorter exposures and no appreciable loss of quality.

Photographers on location

Despite its many encumbrances, and the less than straightforward coating and processing disciplines it imposed on photographers, the wet collodion process had one great advantage: the ability to produce high-quality photography away from the studio.

Both with the glass negative, and with the unique one-off collodion positive, the ambrotype, it was the freedom to travel with a camera which appealed most to mid-Victorian photographers, amateur and professional alike. In order to enjoy that freedom, photographers were apparently willing to burden themselves with a strange assortment of mobile darkrooms, either on wheels or packed into enormous and heavy backpacks.

Roger Fenton's remarkable series of pictures of the Crimean War was produced with the help of a horse-drawn darkroom, converted from a

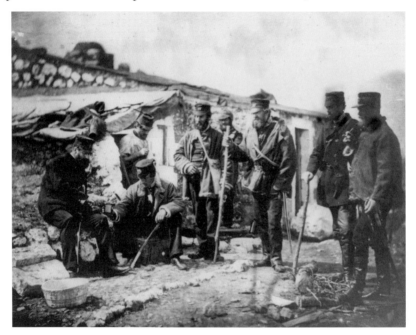

Group of officials, Crimea: one of 360 wet collodion photographs produced by Roger Fenton and processed in his horse-drawn darkroom (see page 60), which was specially transported to the Crimea on board the same ship as Fenton, Sparling and much-needed clothing and supplies for the troops. The darkroom was Fenton's sleeping quarters as well as the coating and processing facility. Sparling slept on the ground beneath the wheels.

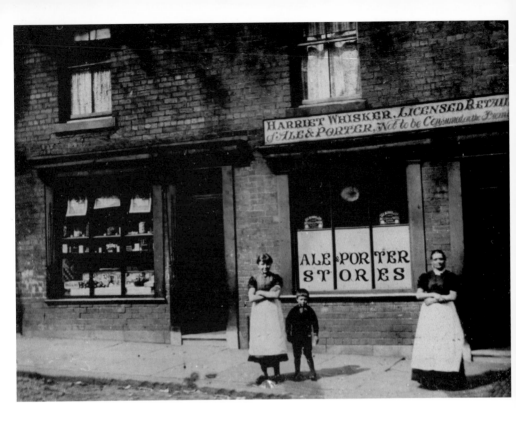

Lyulph's Tower, Ullswater.

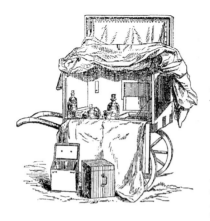

Left: *A wheelbarrow darktent, a design proposed in 1859, offered reasonable working space for the photographer travelling only walking distance from home.*

Below: *In this contemporary engraving of a wet collodion photographer ready for a walking holiday, everything needed was carried on the photographer's back. In this unstable cradle are the camera, tripod, darkslides, plates, chemicals, the tent itself and a box-seat for the photographer to sit on.*

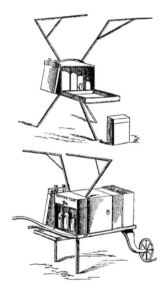

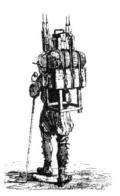

Left: *Two contemporary line drawings of the wheelbarrow darktent proposed by Henry Peach Robinson in the Journal of the Photographic Society, in April 1859. Not willing to rely on local water supplies, Robinson's wheelbarrow carries the additional weight of a water tank.*

Opposite page (top): *Harriet Whisker, ale and porter stores, Manchester, 1870s: quarter plate ambrotype, photographer unknown. Images like this are a rich source of historical information. Harriet Whisker, licensed retailer of ale and porter to be consumed on the premises, was, we learn, an agent for George Munro & Company's bottled ale and porter. Munro had premises in Wigan, Blackburn and Bolton. The shop next door advertised two brands of black lead on posters in the window.*

Opposite page (bottom): *Lyulph's Tower, Ullswater, photographed by Thomas Ogle of Penrith: carte de visite print from wet collodion negative, late 1860s. Ogle was one of many Lakeland photographers who made a living by touring the area and photographing every important building and scenic view to meet the huge demand from the growing tourist market.*

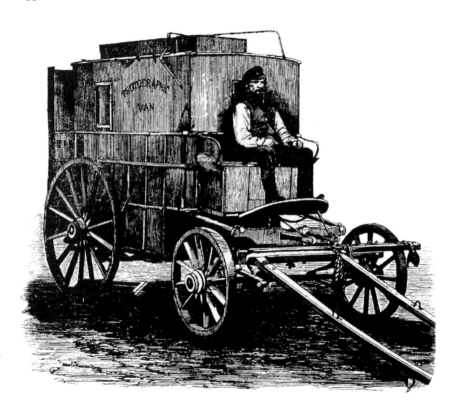

Roger Fenton's famous photographic van from his Crimean expedition in 1855, with William Sparling, his assistant, on the box. Sparling later wrote one of the most important manuals of mid-Victorian photography, 'The Theory and Practice of the Photographic Art'. In his lecture to the Photographic Society upon his return from the Crimea, Fenton went into considerable detail about the fittings of the van, and the equipment and materials which had accompanied him on the journey:

'I took with me a camera for portraits fitted with one of Ross's 3-inch lenses, two cameras made by Bourquien of Paris, of the bellows construction, and fitted with Ross's 4-inch lenses, and two smaller cameras made by Horne and fitted with their lenses, but in place of which I subsequently employed a pair of Ross's 3-inch lenses with which I had previously worked. The stock of glass plates was, I think, 700, the three different sizes, fitted into grooved boxes, each of which contained about twenty-four plates: the boxes of glass were again placed in chests so as to ensure their security. Several chests of chemicals, a small still with stove, three or four printing frames, gutta percha baths and dishes, and a few carpenter's tools, formed the principal part of the baggage. I must not forget, however, what was to be the foundation of all my labours, the travelling darkroom... When it entered the service of the Art, a fresh top was made for it, so as to convert it into a darkroom, panes of yellow glass with shutters, were fixed in the sides... round the top were cisterns for plain and distilled water... on the sides were places for fixing gutta percha baths, glass dippers...'

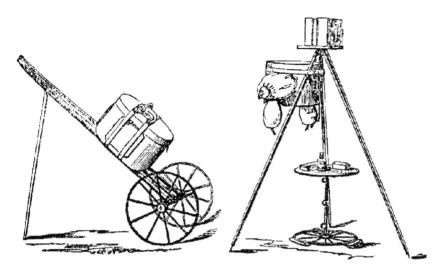

Mr Heineken's darktent was a model of simplicity. It was lightweight, compact and carried no excess weight. Every component of the buggy itself was an essential element of the camera outfit.

Canterbury wine merchant's van, and specially transported out to the Crimea. The horses were bought en route and had to suffer only the Mediterranean part of Fenton's voyage. The van served as the coating and processing room, equipment store and accommodation for the intrepid Fenton. His assistant, William Sparling slept underneath, on the ground, between the wheels. In marked contrast to the high temperatures Fenton experienced while trying to take photographs during the day – by early morning the heat inside the van was sufficient to make the ether boil on the surface of the plate – the temperature in the Crimean night dropped suddenly and significantly. Sparling's sleeping quarters were not likely to have been warm. As the van was filled, by day, with the noxious fumes from the ether, which, with guncotton, made the collodion mixture, and those same chemicals were stored within twenty-four hours a day, it is doubtful if Fenton did get the better of the bargain.

Not all wet collodion photographers had to work in such exotic locations under such demanding conditions, but all those working away from home did need their portable darkroom. Of the early processes only the Waxed Paper Process, pioneered by the Frenchman Gustave le Gray, allowed photographers the luxuries of preparing their materials a

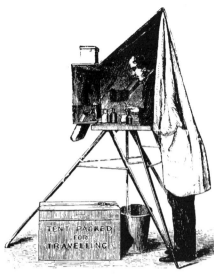

A typical portable darktent from the 1850s, this design offered the photographer very little space in which to work and, perhaps of greater importance, little opportunity for the ether fumes to disperse. With the draw strings around the photographer's waist drawn tight to keep out extraneous light, the noxious ether fumes were trapped inside. Many photographers suffered long-term health problems through working in such conditions.

Inside the darktent, shelves contained the bottles of chemicals, while at the front there was a small work bench. The canvas cover, usually yellow in colour, allowed some light to penetrate, but of a colour to which the wet collodion plates were insensitive.

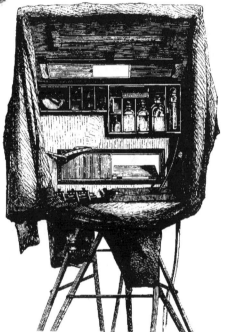

Opposite page: *In this enlarged detail from a typical Roman architectural view taken about 1860, the photographer has parked his wheeled darktent beneath the Arch of Constantine, taking advantage of the additional shade thus provided. The wet collodion photographer typically used whatever shade was available. Francis Frith records that on his trips to Egypt on more than one occasion he sought the cool and dark of a burial chamber beneath one of the pyramids in which to coat and process his wet collodion plates.*

few days in advance of their photographic expedition and processing them up to two weeks afterwards. Few professionals used Waxed Paper, however, as the greater opacity of the paper negative multiplied printing exposure times by four or five times, dramatically reducing the earning potential of any negative.

All views, whether large format prints, small stereos or even *cartes de visite,* produced in the 1850s, 1860s and well into the 1870s were produced by a photographer who transported the processing facilities to the location.

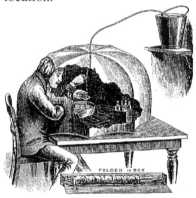

Above left: *'The Eclipse Developing and Changing Tent' was designed for use whenever a proper darkroom was unavailable. According to advertisements for the product, it could be suspended from the bough of a tree, or set out on the dining table as illustrated. It cost 25 shillings for the smaller size, and 35 shillings for the larger one, a considerable expense.*
Above right: *The table-top suitcase darktent from the mid 1860s used a design which continued to be marketed into the 1920s.*

Top: *'Ruins of the Session Hall and Circular Church, Charlestown, South Carolina'; a stereoscopic view from the American Civil War, 1864, photographer unknown.*
Above: *'York Minster, West End' by George Washington Wilson, late 1860s. Wilson's photographers visited the most popular tourist attractions again and again, constantly updating their negatives to ensure the prints which were on sale faithfully recreated the actual scene. York Minster was photographed so often that there are at least three different stereo views showing the progress of the demolition of the buildings which once stood on the cleared site to the right of the church.*
Opposite page (bottom): *'Stoneybyres, Falls of Clyde', a stereoscopic card from James Valentine's 'Scottish Scenery' series, 1860s. Valentine's work is of outstanding quality. Like many photographers, he used the same wet collodion negatives for the production of stereoscopic print pairs as for the smaller carte de visite prints.*

For images which were expected to sell well, the photographer might produce six or more negatives. Glass was fragile and, as printing was a labour-intensive procedure often carried out by casual staff, the risk to the negatives was considered to be high. Whatever the photographer's commercial plans, the portable darkroom or darktent was just as important for the single ambrotype as it was for the negative from which prints would sell in their hundreds.

'The efforts of Photographers to obtain landscape sketches with the Collodion process, have long been impeded by the weight of the apparatus and chemicals to be carried. The difficulty is now obviated by the invention of The Collodion Knapsack, which answers the three-fold purpose of the Packing Case, Camera, and Dark Chamber; and enables the Photographer to manipulate out of doors without the assistance of a tent. The materials which accompany the Knapsack are packed in the smallest possible space.' Thus read a full-page illustrated advertisement in the 21st May 1857 edition of the prestigious *Journal of the Photographic Society*, one of many contemporary advertisements extolling the virtue of a variety of intriguing solutions to the collodion photographer's need for a portable darkroom of some kind.

The advertisement continued: *'The dimensions of a Knapsack for pictures 7 inches by 5 inches are not more than 16 inches by 11, and 6 inches thickness. The following apparatus is packed in this space:– Three Gutta Percha Bottles for Water, Gutta Percha Developing Tray, Collodion Bottle, Varnish Bottle and Spirit Lamp, Lens, Nitrate Bath, Plate Box and Plates, Reserve Box with Bottles of Chemicals, Funnel, Glass Cloths, Dusters, &c.*

The price of the entire apparatus and fittings for pictures of the above size is £10 10s. The weight is about 18 lbs., and it has been found that from the position of the Knapsack on the back a greater weight may be carried long distances without inconvenience.'

The tent had several functions. Firstly it had to be large enough when erected to contain the chemicals, the glass plates, a working surface and enough room for the operator. Next, it had to be constructed in such a way that sufficient non-actinic light could enter to allow the photographer to see what he or she was doing, and thirdly it had to be transportable by whatever means the user had at his disposal.

There may well have been a hierarchy in darktents, for they ranged in size from very small one-man efforts which could be folded down into a bundle small enough to strap to a backpack, to large and commodious constructions which required a horse and carriage to move them about. Indeed, some had so much space that tables and chairs went inside, allowing the operator the luxury of preparing coating and then processing the plate in the comfort of an upholstered chair and a folding table while

The sailing vessel 'Industry' beached at low tide in Fleetwood harbour on the Lancashire coast, photographed in the mid 1850s by Harold Petschler. Petschler was the founder of the Manchester Photographic Company, which became one of the region's major publishers of stereos and cartes de visite.

the assistant stood and looked on.

The comfort afforded by the larger tent was considerable. Reference has already been made to the fact that the ether fumes of the wet collodion process in a very confined space constituted a significant health hazard, so the larger the tent, the more air there was to breathe.

While the rich, wealthy and less adventurous photographers made much of the value of size, of robustness and of space and comfort, the more intrepid cameramen and women marvelled at the lightweight construction of some tents, and their ability to be backpacked. The 'Photographic Knapsack' could not be further removed from the horse-drawn sophistication of Fenton's Crimean van. In between those extremes there were darktents of just about every shape and size, each advertised proudly by its designer, claiming for it qualities guaranteed to make the lot of the photographer easier at a stroke.

Letters from satisfied customers were a frequent part of any successful advertisement. James How, once a photographer of repute himself but by 1864 a successful dealer, designed 'How's New Photographic

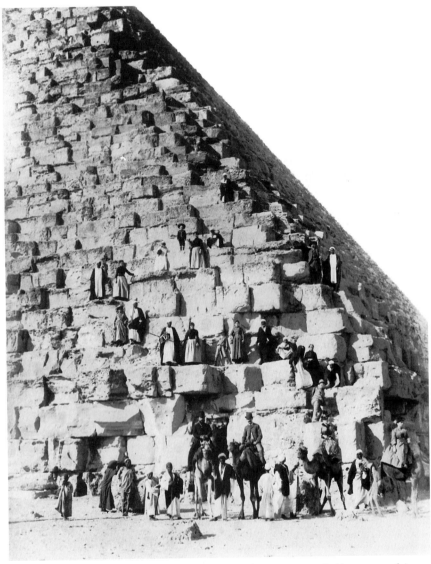

This remarkable image from the Victorian Grand Tour was probably processed in a nearby tomb or cave. The image itself offers an unusual insight into the complex rituals and relationships which were central to mid nineteenth-century class structure. Upper class British women, with a paranoid fear of foreigners in general and Arabs in particular, found themselves dependent on those same Arabs to help them surmount the steep steps of the pyramid. Climbing the pyramid was part of the 'rites of passage' of the tour, so for a few brief hours the established order was abandoned in order to scale the heights.

Tent' to fit into a small portmanteau measuring 24 by 18 by 6 inches
(61 by 46 by 15 cm) and weighing only 'about 20 lbs' (9 kg). One
customer, George Spencer, wrote from his Cannon Street address in
London that he found *'the new Tent everything that can be desired, very
light and portable, convenient in use, and quite non-actinic in the full
sunshine; we have given it a good practical testing, and think we have
no further trouble about our open air work.'*

It was due to the collodion process and the portable darkroom, in
whichever guise was considered most appropriate, that the great pub-
lishing empires of George Washington Wilson in Aberdeen, Francis
Frith in Reigate, James Valentine in Dundee and many others were
created. These photographic publishers proclaimed their intention to
offer for sale photographs of every town, city and village in Britain. To
a large extent they succeeded, and their legacy of time-locked images of
Victorian Britain stands today as a major historical source of reference.

In every region of Britain other photographers sought to do the same
within their own neighbourhoods. In the English Lakes competition
was intense, with several important studios vying with each other for
the growing tourist and mountaineering market. The Abraham studios
in Keswick competed directly with Alfred Pettit, whose studio was only
a few doors away. The work of both covered scenic views of Lakeland
and, thanks to the Abraham brothers' passion for mountaineering, some
of the most dramatic views of the Lakeland peaks ever produced. At
Watchet in Somerset James Date's photography in the 1860s recorded
the rebuilding of Watchet harbour and the construction of the West
Somerset Railway. In a thousand studios in a thousand other towns and
cities the story was the same: local photographers chronicling the de-
velopment of their localities. That many of them also sold their finest
views to Frith, Wilson, Valentine and others explains the nationwide
coverage which was achieved by these major photographic publishers.

Waxed Paper photographers did not need portable darkrooms, but
they obviously felt the need to process their views before moving from
one location to another. While their collodion counterparts used tents
and wagons, the Waxed Paper photographers processed their images in
hotel bedrooms overnight. More than one account of a paper photo-
grapher's experiences on location makes reference to silver nitrate stain-
ing bed linen or the contents of the photographer's portmanteau. Other
accounts mention the challenge of collecting rainwater from hotel roofs
to prepare for the processing requirements of the following day.

For other photographers, a lighter and more easily portable solution
beckoned: *'The aim in the construction of this camera has been to
obviate the necessity of a tent or a darkroom, whilst performing any of
the operations necessary for producing photographic pictures. The cam-*

Above: *Thomas Short stands proudly outside his leather shop c.1870: quarter plate ambrotype, photographer unknown. Glare from the painted fascia, combined with a long enough exposure to retain detail in all the leather goods, has all but bleached out Short's name.*

Opposite page (top): *A group of brickmakers, photographed on a Manchester building site, 1865-70. This sixth plate ambrotype, collodion positive, is typical of the type of material produced by itinerant photographers whose work was often speculative rather than commissioned. The frame is made of wood covered with printed paper and backed with cardboard. The pressed metal matte is paper thin, as is the metal binder. The photographers who took these views of our Victorian predecessors at work never identified themselves, yet their work gives us a valuable insight into the occupations and working methods of the period.*

Opposite page (bottom): *The shopkeeper and his two young assistants pose for the camera outside their Midlands music shop: quarter plate framed ambrotype, c.1870, photographer unknown. Above the shop a sign reads 'Pianofortes, American Organs, and Harmoniums for sale' and 'Every description of musical instrument tuned and repaired'. The windows are filled with Christmas decorations. Above the shop were the offices of the Salopian Aerated Water Company, J. B. Davenport, Proprietor.*

All these images were fitted with a small ring at the top so they could be hung on a prominent wall inside the premises. They are presented in cheap wood and paper frames, with the cheapest possible pressed metal surrounds. It is ironic that such valuable historical images come from the bottom end of the market.

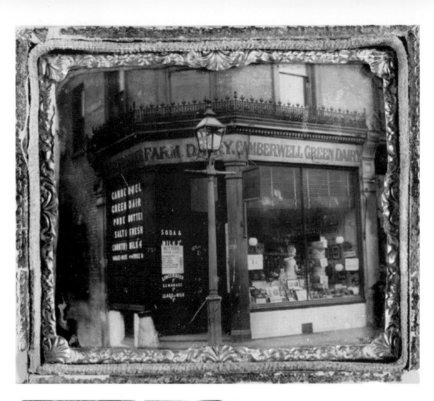

Opposite page (top): *Camberwell Green Dairy, photographed c.1875: photographer unknown. Despite its relatively small size and low original cost, the quality of this sixth plate ambrotype image is extremely high. The price list by the door includes 'Soda & Milk 2d, Ginger Beer 1d, Lemonade 1d, Glass of Milk 1d, Ceylon Tea 2/-'. A separate butter price list (the white notice to the left of the door) lists 'Finest Irish 1/-, Sweet Danish 1/2, Best Dorset 1/4, Lepelletiers Brittany 1/4, Our Noted Devonshire 1/5'. At those prices, butter was clearly a luxury item in Victorian Camberwell.*

Opposite page (bottom): *Ladies seated on a park bench: sixth plate ambrotype, c.1880; photographer unknown. The lady on the left is either making lace or crocheting: the other two are engaged in animated conversation. Images like this were produced by itinerant photographers working in parks, beaches and other public places during the summer season, rather in the manner of holiday camp photographers in the 1950s and 1960s. They frequently employed cameras with integral processing as described in the text. The frame and fittings are identical to those used for the brickmakers (page 70) more than a decade earlier*

Below: *Father and children on the beach, c.1880. Beach photographers were a common part of the Victorian seaside experience from about 1870. Many contemporary views of crowded beaches show a photographer's booth, often with a makeshift daylight studio tent. No less typical, in Victorian Britain, was the itinerant beach photographer offering a unique sixth plate ambrotype or tintype in a simple paper-covered wooden frame for 6d. The formality of dress hardly seems appropriate for a seaside holiday.*

era I now submit to your notice folds up when not in use, which renders it portable for travelling, at the same time it is capable of containing all the chemicals, &c. that are required.'

With these words Frederick Scott Archer, better known as the man who made the collodion process a practical proposition, introduced his lecture to the third meeting of the newly established Photographic Society on 7th April 1853. The lecture was entitled 'On a Camera where the whole Process of a Negative Picture is completed within the Box itself'. He had first proposed this combination of camera and darktent as early as 1851, at the same time as he had announced the first practical application of wet collodion.

The camera was designed for use with most of the processes in use in Archer's day, with the exception of the daguerreotype with its more complex sensitising process. In his lecture, Archer alluded to the system being equally easy to use with calotype, other dry plain paper

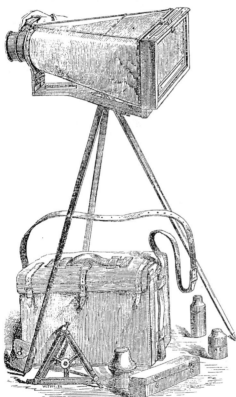

This camera was designed by Joachim Otté as the ideal lightweight equipment suitable for the landscape photographer. It was equally recommended for waxed paper and for wet collodion. According to the advertising for the outfit, this was the 'Complete Apparatus. The whole of which, except the legs, can be packed in the knapsack'.

This illustration of the camera comes from Otté's book 'Landscape Photography; or, A Complete & Easy Description Of The Manipulations And Apparatus Necessary For The Production Of Landscape Pictures, Geological Sections, Etc. By The Calotype, Wet Collodion, Collodio-Albumen, Albumen, Gelatine, And Waxed Paper Processes. By the Assistance of Which, An Amateur May At Once Commence The Practice Of The Art', published by Robert Hardwicke of 192 Piccadilly, London, in 1858.

A novel feature of the camera was the use of leather conical bellows. The concertina bellows which became typical in cameras had not been introduced when this camera first appeared.

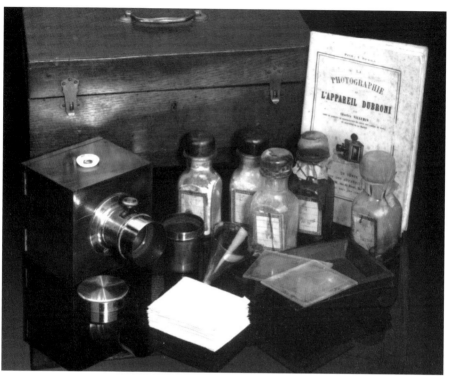

The Dubroni camera was designed and manufactured by Bourdin of Paris ('Dubroni' is an anagram of 'Bourdin') as an alternative to carrying a portable darktent or dark-room. The camera was the first of many which were completely self-contained. The plate could be coated, exposed and processed without being removed from the camera. The Dubroni outfit was available in a number of sizes. This smallest size, dating from 1864, took tiny images measuring only 2 inches (5 cm) in diameter.

processes, wet paper and wet collodion on glass. Although he was probably the first to demonstrate a collodion camera and darktent combined, a camera for taking and processing daguerreotypes had been the subject of a patent ten years before Archer's 1851 proposal. Antoine Claudet, one of the finest portrait photographers in London and a leading user of the daguerreotype process, included just such a camera in his 1841 patent number 9193.

Claudet wrote: '*By the second part of my improvements the operations which heretofore required two distinct processes may now be conducted simultaneously into one. This is effected by applying within the camera obscura the vapours of mercury at the same moment that the light is producing the effect upon the plate, so that the two opera-*

tions of the light and the mercury, which were separate and consecutive before, are now performed at one time.'

As far as can be ascertained, there are no easily obtainable records of the system ever working successfully, but at least the idea was ingenious. It involved a cup of mercury fitted to the base of the camera, with a spirit lamp beneath it, heating the mercury and causing the vapours to rise over the exposing plate. The patent described how Claudet looked in through red or yellow glass to see how the plate was progressing and, when it was exposed/developed to his satisfaction, it was removed from the camera, 'requiring only the washing process'. The patent, surprisingly, made no reference to fixing the plate, so catastrophe would have befallen anyone following the patent instructions to the letter.

Archer, however, in describing a practical version of his system ten years later, was recognising early on in the life of the wet collodion process the challenge he was setting itinerant photographers by requiring them to carry with them all the paraphernalia of processing tents or carriages. By coating and processing in camera, the bulk the photographer had to transport on location was significantly reduced. He was also setting photographic invention in a direction in which it has continued to the present day, culminating in the sophisticated instant picture cameras of today. The Archer camera also served as a packing case for all the chemicals and utensils and was advertised as being able to carry, in a single box, everything needed to make wet collodion pictures 10 by 9 inches (25 by 23 cm).

An early advertisement for the 'Omnium', a modification of Archer's design by the camera makers B. Hockin & Company, announced: *'Manipulation of this camera is most facile, and may be acquired by anyone, having already some knowledge of photography, in a few hours. It is adapted for lenses from 4 to 20 inches focus. It is very light and strong, and measures when folded (with sufficient room inside for all the necessaries, except water, for nine collodion pictures 10 by 9 inches) 20 by 12 by 5 inches. Price without lens £5.'*

Henry Fox Talbot also suggested the idea of a combined camera and processing facility in his 1851 patent number 13664, but the idea was considered so fanciful in his day that it apparently never went beyond the patent specification. Talbot's version involved a glass cell with a funnel at one of the top corners for filling, and a drain cock and hose pipe at the opposite (bottom) corner for draining. With this elaborate system, and partially prepared albumen on glass plates, Talbot proposed that the final nitrate sensitisation of the plates and the subsequent processing after exposure could all be completed with the plate still in its glass cell. He proposed a light-tight curtain as the protection for the plate whilst sensitising was taking place. He even proposed that expo-

Watchet harbour being rebuilt after a great storm. Each image is half of a stereoscopic ambrotype by James Date, 1861. Although his studio was relatively nearby, the speed at which the wet collodion photographer had to work on location would have necessitated a darktent or mobile darkroom being close at hand.

Frederick Scott Archer's patent camera with internal processing tanks, designed for the photographer who wished to travel light.

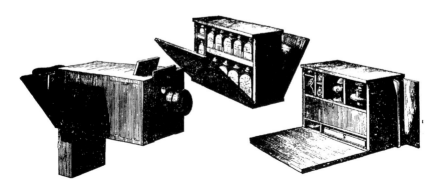

A little girl photographed on holiday with her favourite doll, an opportunist picture taken by an unidentified itinerant photographer c.1875, probably using a camera with internal processing facilities.

A mother and daughter equipped for the beach, c.1875.

A sixth plate tintype, c.1880, in a case with 'Forget-me-not' printed on the cover – typical of the output of fairground photographers working with internal-processing cameras in the 1880s and 1890s.

sure could be carried out with the plate still immersed in the sensitising liquid, with an alternative method which required the nitrate to be drained off but the plate to be exposed through the (presumably wet) wall of the protective glass cell.

Archer's version, on the other hand, proposed the use of a processing tank suspended beneath the camera – an idea taken up by several others after 1852. Indeed Frederick Newton, a fellow member of the Society, lectured on his design just after Archer had completed his talk. New-

ton's version, also patented, differed from Archer's in the method adopted for coating and processing. While Archer had rubberised sleeves built into the sides of the camera so that the user could physically manipulate the plate from sensitising tank to exposing position and then through the processing cycle, Newton's version had an ingenious system of rods which raised and lowered the plate from tank to tank. The tanks, like Archer's, were suspended below the camera body.

Of all the inventions of the Victorian era which permitted coating and processing within the camera body, perhaps the best-known was the Dubroni camera introduced in 1864 and patented by Bourdin of Paris. While other ideas had centred on the principle of moving the plate from the coating tank to the focal plane and then to the processing tanks, Bourdin proposed a system whereby the plate remained in the focal plane at all times, and the sensitising and processing chemistry was introduced to the plate by tilting the camera. A pipette with a rubber bulb at the top was used both to inject a chemical into a glass bowl in the camera base and then to withdraw the used liquid before replacing it with the next chemical. A yellow or orange window illuminated the camera interior during processing, the progress of which the photographer could observe through the lens.

To avoid contamination, the camera interior had to be cleaned carefully after any period of use. It was, however, immensely successful and achieved such popularity that it was soon available in half a dozen sizes, ranging from a tiny version which produced a circular picture just under 2 inches (5 cm) in diameter (and cost £2 in 1867 complete with lens) up to a whole plate version with bellows focusing and costing £35, a small fortune in the 1860s. The larger versions dispensed with the glass internal trough, using instead a separate 'box' at the back of the bellows camera rather like a processing dish without the bottom. The glass plate, held in place by strong springs, effectively formed the bottom of that dish when the chemicals were introduced and the camera tilted on to its back.

As can be seen from the illustration on page 75, the Dubroni outfit offered the photographer a complete system including all the chemicals and utensils which were supplied arranged around the camera in a fitted case. Cameras like the Dubroni were ideally suited to the production of ambrotypes away from the glasshouse studio. The f/4 lens, with which the smallest of the range was fitted, permitted portrait exposures of five to ten seconds outdoors.

A year after the introduction of the Dubroni, Charles Piazzi Smyth, Astronomer Royal for Scotland, used a camera of his own design to take photographs of the interiors of the pyramids by magnesium flash. It contained four plates measuring 3 inches by 1 inch (7.6 by 2.5 cm).

Francis Frith produced this image of carved sculptures on the walls at the Temple of Dendera in Egypt in 1857. The conditions under which he worked were appalling – intense heat often drying the collodion before he could spread it evenly. Indeed, the streaks at the edges of this image show just that problem. Sometimes he used a darktent for coating and processing, sometimes the interiors of tombs. He also had a processing facility set up on board the boat on which he travelled the Nile, and for more remote locations he had a photographic carriage. In his account of his work he wrote that he had 'constructed in London a wicker-work carriage on wheels, which was, in fact, both camera and developing room, and occasionally sleeping room.... This carriage of mine, being entirely overspread with a loose cover of white sailcloth to protect it from the sun, was a most conspicuous and mysterious looking vehicle, and excited amongst the Egyptian populace a vast amount of ingenious speculation as to its uses. The idea, however, which seemed the most reasonable, and therefore obtained the most, was that therein, with right laudable and jealous care, I transported from place to place – my harem! It was full of moon-faced beauties, my wives all! – and great was the respect and consideration which this view of the case procured for me.'

This camera was effectively built round a processing tank and appears to have been the first camera to combine the dual benefits of internal processing and the ability to be pre-loaded with several plates.

The widest application of internal processing technology was probably at the lowest end of the photographic market – the lowly tintype. One of the most successful tintype designs was introduced in the 1890s

by Jonathan Fallowfield of London, who produced a combination of a simple hinged camera and a processing tank whereby, when the camera was located over the processing tank, the exposed plate dropped into the developing tank through a light-tight seal.

Many other designs followed from both British and French makers, and almost every fairground photographer in Europe must have sported just such a device over the following thirty years. Designs like the Velophot from Austria continued to be produced well into the 1920s, with additional refinements such as binocular viewing lenses at the back so that processing could be observed more easily.

Presenting the portrait

The high initial cost of photography, making it available only to the wealthy, played a significant role in the evolution of the packaging styles used to present the portrait to its customers. For the wealthy, it was seen as the technological miracle which would replace the miniature painting – the concept of 'nature painting herself' occurring frequently in early accounts of the daguerreotype. Thus the small size and unique character of the daguerreotype was turned to its advantage, and

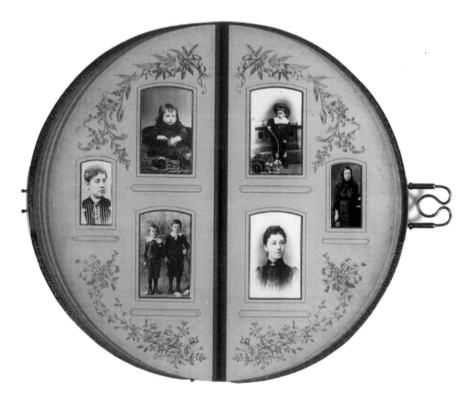

An unusual late Victorian circular family album dating from c.1885. The family album was a treasured possession, and photographs of family and friends were mounted alongside those of the rich and famous. Early albums were simple plain leather affairs, but by the 1870s examples in mother of pearl, carved wood, moulded plastic, painted papier-mâché and even jewel-encrusted ivory were available for those with the money to buy them.

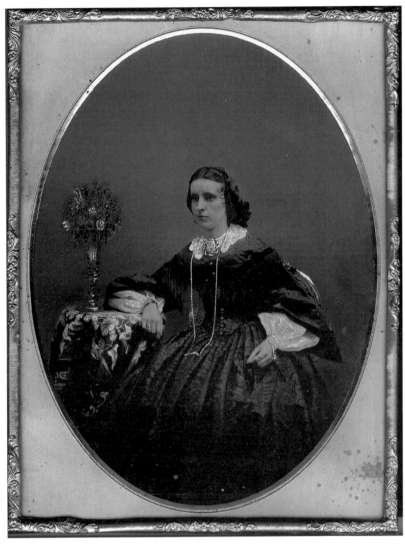

Portrait of a lady, photographer unknown, late 1850s: a whole plate ambrotype, tinted and gilded. The image, which is reversed left to right, is richly coloured, using gum-based paints for the vase of flowers, the tablecloth and the lady's dress, and probably dry pigment for the tinting and shading on the lady's face. Her necklace is picked out in gold paint, as is the gold bracelet round her right wrist, the pinchbeck photograph brooch at her throat, and the rings on the fingers of both hands. Her wedding ring appears to be on the fourth finger of her right hand – resting on the table. Despite the effect of a richly coloured image, only four colours plus gold have been used in its execution.

necessity became a virtue. The unique, direct positive was a necessity of the process, but the manner of its marketing ensured that the infant art of photography was invested with the same mantle of exclusivity which had hitherto been worn by the miniaturist. That 'preciousness', that value, governed and informed photography's preferred presentation styles for decades. In the earliest years of the daguerreotype, the photographic portrait was packaged in exactly the same frames and cases which had been manufactured for miniature paintings.

Initially, the one aspect of the photograph which failed to match up either to the miniature painting or to nature was the absence of colour. Early in the history of photography, Robert Hunt, a chemist and a prodigious writer on photography, wrote: '*It is true that three years have passed away, and we have not yet produced coloured images; yet I am not inclined to consider the hope as entirely illusive.*' It would be half a century before a practical colour photography process became viable.

When the first public announcements of photography appeared, the daguerreotype plate was greeted, by a society obsessed with invention and innovation, as being so close to perfection that nothing could be expected to improve upon it. As one newspaper eloquently described it, nature was the artist and the photographer was merely a secondary agent, able neither to flatter nor to detract from the subject placed before the camera.

Unfortunately, but perhaps understandably, that honeymoon period was short and was very quickly replaced by a series of recurring doubts about whether photography could ever reach a level of sophistication which might render it useful. The debate about whether or not photography was an art began at the same time and is still to some extent unresolved.

The absence of colour was central to the growing dissatisfaction with photography. A number of suggestions for colouring photographs by hand had been proposed as early as the mid 1840s, and Richard Beard himself patented a colouring method by 1852. When sophisticated colouring became possible, studios offering the service were both profitable and popular. Purists, if such they can be called, did not approve of colouring at all, and Henry Snelling, in his 1849 volume *History and Practice of the Art of Photography,* made his views well-known early in his text:

'I very much doubt the propriety of coloring the Daguerreotypes, as I am of opinion that they are little, if any, improved by the operation, at least as it is now generally practised. There are several things requisite in an artist to enable him to color a head, or even a landscape effectively, and correctly, and I must say that very few of these are possessed

*by our operators as a class. These requirements are, a talent for draw-
ing – taste – due discrimination of effect – strict observance of the
characteristic points in the features of the subject – quick perception of
the beautiful, and a knowledge of the art of mixing colors, and blending
tints. The method so pursued, I do not hesitate to say, and have no fears
of being contradicted by those capable of criticizing, is on the whole
ruinous to any daguerreotype, and to a perfect one absolutely disgusting!'*

A few years later, however, colouring had become the norm rather
than the exception, and Snelling was in the minority, but he was not
alone, as the American studio of Southworth and Hawes refused to tint,

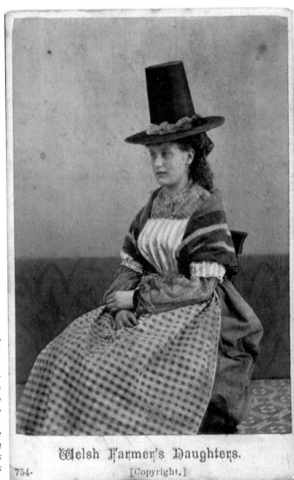

*The market for com-
mercially produced
cartes de visite was im-
mense, and highly col-
oured examples like
this 'Welsh Farmer's
Daughter' sold widely
in both carte de visite
and stereo formats.
Colouring images like
this was carried out on
a production-line basis
to keep the unit costs
down.*

Welsh Farmer's Daughters.

754. [Copyright.]

and the Frenchman Arago believed that: *'to hand tint a lovely image, even by the hand of a reputable artist, is as if to set a signwriter to retouch the wings of a butterfly.'*

Colouring daguerreotypes was, however, an increasingly popular requirement of the image-buying public, and several approaches to the task evolved.

The most widespread involved carefully painting those areas of the plate to be coloured with a thin layer of gum arabic or isinglass – so thin as to be invisible – and then letting it dry. The artist, often a miniature painter by training and preference, would then apply the

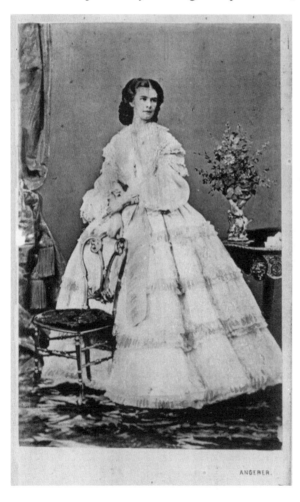

The Empress of Austria, photographed by Angerer in the 1860s. This carte is cleverly coloured with only four or five tints, yet giving it a 'full colour' appearance. Records do not reveal just how large the editions of these cards were, but presumably they were substantial.

colour using dry powder pigments and a dry soft sable brush with a fine point. The gum was first rendered tacky by breathing lightly on it, ensuring that the pigment powder would stick and that the surface remained very delicate and susceptible to abrasion. The whole process was carried out with the aid of a magnifying glass, and the best colourists were so good that their work shows little or no evidence of brush strokes.

Central to their success was an ability to mix realistic colours and to apply the essential tints, tones and shading necessary to make the colour lifelike. In that respect at least Snelling's words of caution were appropriate: done badly, the effect was terrible. However, executed well, it was stunning and, in many instances, surprisingly realistic. The flesh tones applied to faces and hands, and the rouged effects on cheeks, were the result of considerable experience both in colour mixing and application. Clothing was not just coloured but shaded, and jewellery highlighted with either gold leaf or a gold paint applied with considerable care. The ability of the artists to colour large areas was particularly noteworthy. Indeed, the tinting on some celebrated daguerreotype nudes, where entire bodies were tinted and graduated with remarkable artistry, was so convincing that the casual viewer could be forgiven for thinking momentarily that the colour was natural.

Despite his misgivings, Snelling offered detailed advice on colour mixing and colour preparation in his 1849 book:
'*The method of laying colors on daguerreotypes is one of considerable difficulty inasmuch as they are used in the form of perfectly dry impalpable powder. . . . The writer is confident that some compound, or ingredient may yet be discovered which, when mixed with the colors, will give a more delicate, pleasing, and natural appearance to the picture than is derived from the present mode of laying them on, which in his estimation is more like plastering than coloring. . . In coloring daguerreotypes, the principal shades of the head are made with bistre, mixed with burnt sienna, touching some places with a mixture of carmine and indigo. . . The flesh tints are produced by the use of light red, deepened towards the shaded parts with yellow ochre, blue and carmine mixed with indigo, while the warmer more highly coloured parts have a slight excess of carmine or lake.*'

If the sitter was wearing diamonds, some finishers created pinpricks through the image to the silver of the plate itself; that slight scratch caused the 'jewels' to appear to sparkle when the image was moved near a light.

When the ambrotype came into vogue in the early 1850s, methods changed somewhat. The same dry powder pigments were used, but applied directly on to the collodion image, as the collodion itself could

easily be rendered tacky enough to accept the pigment by breathing on it. With the passage of time, this has proved not to be permanent in many instances, and the colours have lost their adhesion to the image. With many ambrotypes, all that remains of the artist's work is the gilding (gold leaf ground into a gum mixture) applied to rings, necklaces and watch chains.

An alternative method was to paint the colour on to the image surface using gum-based paints. This gave stronger colour, but the brush strokes were impossible to conceal, and under some lighting the colour can clearly be seen as a surface application. In some fine examples, faces and clothing were coloured using the more subtle approach, while the vibrancy of flowers was achieved with stronger colours.

There is no doubt that the photographic studios which provided this service saw themselves as artists, just as much as those who used paint exclusively. Indeed many photographic portrait studios also offered a 'traditional' painted portrait as an alternative to a photograph and they all offered a service to paint a portrait from a photograph.

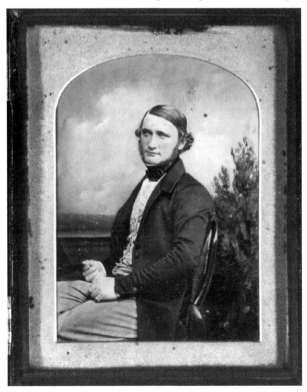

This tinted daguerreotype by William Kilburn was taken at his studio at 234 Regent Street, London, between 1852 and 1855. It epitomises the skills of the colourist, with delicate shading to the clouds, natural tints to the subject's facial tones, and a realistic landscape beyond. Even under a high-power glass, no brush strokes are evident. The case is in rich plain burgundy leather, with the photographer's name and address, together with the legend 'By appointment' and the royal coats of arms, embossed and gilded on the front. Later and cheaper cases used leather or paper hinges. This case has two strong brass hinges.

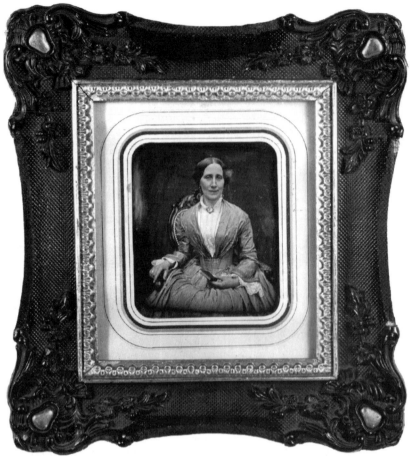

Tinted daguerreotype by Gustav Oehme of Jagerstrasse, Berlin, mid 1840s, presented in a gilded and lacquered wood and plaster frame. Oehme was taught photography by Daguerre himself.

By the time the *carte de visite* craze was in full swing, almost every portrait studio offered to enlarge or reduce photographic portraits, and to have them coloured or painted in every size from the tiny image used in a brooch or a locket right up to life-size portraits and larger.

For the *carte de visite*, the colourists used water-based dyes which penetrated the surface of the print and gave a relatively permanent coloured finish. Owing to the sepia on cream of the albumen print used for all cartes, the colourist had very little to do to the skin tones to make them look good. A slight warming of the cream/sepia skin on the print produced a surprisingly realistic colour. The natural brown of the print

looked coloured anyway, and in many portraits it is apparent, on close scrutiny, that very little colouring has actually been carried out, despite the very realistic appearance.

With cartes costing as little as two shillings for half a dozen tinted prints, the amount of time a colourist could afford to spend on the prints must have been very small. Hand-tinted prints were available on a commercial scale for two old pence each, so it is apparent that adding colour had to be simple and speedy.

As the *carte de visite* craze developed, studios such as J. E. Mayall marketed tinted carte portraits of the Royal Family, and these were available through High Street studios nationwide.

When studied closely, the quality of the colouring can be appreciated, even though they must have been coloured on a 'production line' basis. The fine image of the young Prince Arthur, Duke of Connaught (page 53), uses only four colours, applied with immense skill. A slight 'rouging' is the only addition to the skin tone, and the rest of an apparently 'full colour' effect is created with blue, red and yellow. Red is used on the hair, combining with the natural sepia of the print to produce a rich brown colour.

Colouring the daguerreotype and ambrotype was only part of the production of a Victorian portrait. Selection of a suitable case and the fitting out of that case in a style to suit the customer's taste completed the process.

In Britain and the United States, miniature paintings were, historically, frequently supplied in cases. In continental Europe framing was the more usual form of presentation. It was the same with photography. At first cases for miniatures were put into service for daguerreotypes, but it was not long before case designs especially made for photography were introduced. The 'urn' case illustrated on page 92 is believed to have been the first, introduced before 1842 by the American photographer John Plumbe Junior.

Despite an early preference by British buyers for plain cases, very detailed and elaborate case designs were increasingly common by the mid 1850s. The art of the die-maker, designing and creating the dies with which to emboss cases, developed quickly, giving rise to designs of considerable artistry and beauty. There are no records to tell us how many different designs were produced, but the total must have been considerable. High-quality casemakers generally continued to use plain premium leathers and metal hinges. The mass-producers chose thinner leathers, often over embossed card formers, and leather hinges. Later, even the leather was abandoned to keep costs down, and pressed paper became available in the wide range of designs.

Whatever the material outside, the customer had a choice of interior

Probably the first leather daguerreotype case embossed with a pictorial design, this 'urn and flowers' case is believed to have been made by or for John Plumbe Junior in the early 1840s. This case is one of three housing the early daguerreotypes of mother and daughters illustrated on page 25.

Opposite page: *Four embossed leather cases, typical of designs from the 1850s: (clockwise from top left) 'Romanesque Urn' (c.1857), 'Birds at a Fountain' (c.1857), 'Cupid in a Rose' (c.1855), and 'Bunch of Flowers' (c.1856).*

fittings for the case. Traditionally, the image itself, in its brass matt and frame, was kept in place by a tight-fitting velvet-covered strip of thick card running round the inside of the case recess. On the inside of the lid, a silk or velvet pad, colour-coordinated with the velvet strip, protected the image.

Silk pads were usually white, cream or pink, but velvet pads were available in a much wider range of colours: red, blue, green, brown, pink, purple and various shades of each. Thus the customer could be offered interior fittings for the case which coordinated with the tinting of the image itself. Manufacturers' catalogues from the 1850s make it clear that the pads and fitting were sold separately.

Choice did not stop there: in addition to plain velvet pads, a range of embossed pads was also offered. Geometric designs, floral designs and

scroll designs embossed into the thick velvet were available, with the addition, from some studios, of the photographer's name and address.

Several different gauges of metal were available for matts and frames, with the better-quality furnishings being considerably more expensive. As portraits could vary in price from sixpence, in a frame, to well in excess of one guinea, it is hardly surprising that furnishings were manufactured to a standard which was appropriate to the price being paid for the finished article.

If even the cheapest papier-mâché case was beyond the means of the poorest customer, cheap wood and paper frames like those described by Henry Mayhew's photographic man might be chosen and were also

Mother of pearl and lacquer on papier-mâché case from the mid 1850s. Illustrated here actual size, this sixth plate case still retains the full brilliance of its original colours. As the majority of cases were mass-produced, there would have been considerable value in the exclusivity which came with ownership of hand-painted cases such as this. Despite patterns being used as reference for the painters to work to, no two cases are alike. Rare scenic examples, adorned with churches, castles, lakes and landscapes are all highly treasured by collectors today.

used for the occupational images on pages 70 and 71. However, even with these lower-quality trimmings, the ambrotype was still beyond the reach of the majority of photography's potential customers.

The *carte de visite* was introduced at just the right time. It was cheap, light in weight and robust, in marked contrast to the weight and fragility of a cased daguerreotype or ambrotype. The *carte de visite* was the stimulus which triggered the popularity of the family album. From its introduction in the mid 1850s, the *carte de visite* proved immensely popular. With cartes sold in their millions, albums to house them were produced in quantity by a number of major producers, most notably Marion & Company of Paris.

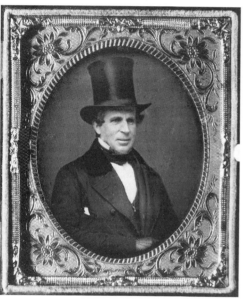 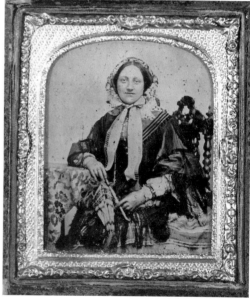

A huge gulf exists between these two pictures. As is evident from the dress of the two figures, the gentleman apparently comes from a financially secure background, while the lady is dressed typically for working class women of the late 1850s. The image on the left, a sixth plate daguerreotype, was taken by a high-quality studio and is packaged in high-quality materials.The gilt matt surrounding the image is finely chased metal, and the frame is of sturdy-gauge pressed metal. By comparison, the right-hand image, an ambrotype by Charles Timms of 41 Newington Causeway, London, is a much inferior product. Both images date from the late 1850s. Timms used a cheap pressed metal matt. and a thin-gauge frame for his work, savings no doubt reflected in his much lower unit price.

*Four carte de visite album designs manufac-
tured between 1865 and 1885. (Clockwise
from top right.) Quarto carte de visite album,
leather on embossed cardboard, a relatively low
cost album from c.1880. A quality embossed leather
album from c.1870. An unusual semicircular album
(see page 83) dating from c.1885. A small album for a
single carte per page, c.1875, with moulded bois durci
(an early plastic) covers, finished to look like carved
hardwoods.*

Initially introduced as a simple, leather-bound volume in which to paste albumen prints, the album went through several different designs in its evolution into the typical examples which are regularly found in antique fairs today.

Early albums were sold with plain pages, which may subsequently have been decorated by the daughter of the house. Typical decoration was based on floral and other natural motifs. Later albums were pre-printed in black ink to simulate the sort of pen, ink and wash work previously added by hand. Later still, album pages were lavishly printed by lithography in many colours, often with gilt work, developing themes from nature, precious stones, flowers, animals, birds and others.

When cartes first appeared on the market, some years after the concept of the family album had been introduced, cut-out masks were marketed especially for the new format. With the masks pasted on to the pages, cartes could be slipped into them and so be held securely without being affixed permanently to the pages.

As the carte became the standard portrait format for the album, thick

Not all cartes de visite were mounted in the family album. By its very nature – brass clasps and all – the album was a private, family affair. A slightly more public presentation style was afforded by the type of concertina-style leather display frames illustrated here. In this example, four favourite cartes could be displayed, while larger versions accommodated six or more portraits.

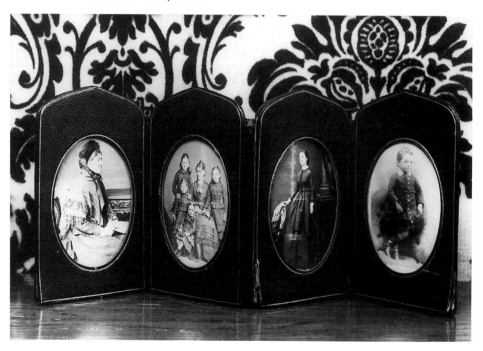

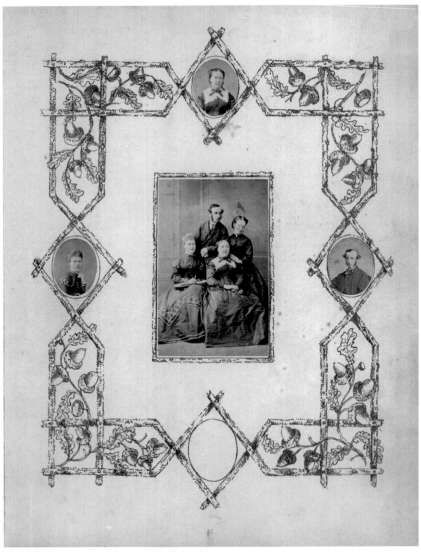

This page comes from an early family album, designed in the days before the slotted page for the carte de visite was the norm. In the centre is an unmounted carte de visite print, pasted straight on to the decorated album page. The perimeter images are hand-cut one-sixteenth plate ovals, produced especially for the purpose, and not just cut-down cartes. The album page is simply printed by lithography to create a facsimile of the sort of hand-drawn decoration which was fashionable at the time. In this album, with twelve printed pages, four different designs are used, the design used most frequently being a vertical column of three ovals cut from carte de visite prints, and surrounded by a rambling rose.

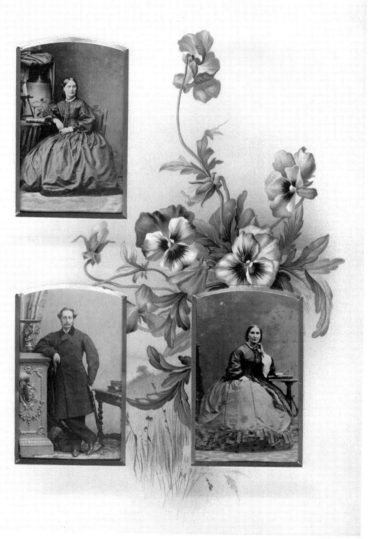

The cartes on this album page are by André Adolphe Eugène Disderi of Paris. Although he did not conceive it, he patented the carte de visite format in France in 1854. In his Paris studio many of the major figures of French art, literature and society posed before his camera, in addition to a wide clientele of middle and upper class French people. It was from about 1856 that the carte de visite format enjoyed its massive popularity, which it retained into the early 1880s, although it vied for popularity by then with the larger cabinet-sized print. This album page, by Marion of Paris, c.1875, has been printed in at least six colours, to give a rich and opulent effect. The album cover is in heavily embossed and tooled leather.

pre-slotted card pages became the norm, allowing cartes to be added or removed at will. It is with this design of album that decoration became most lavish, typically in the 1870s and 1880s. Towards the end of the century, album design became simpler once again.

Album covers went through the full range of styles, from the plain and unadorned to jewel-encrusted extravaganzas. Carved wood, mother of pearl, velvet, pressed metal and lacquered papier mâché with an inlaid cameo were all available, as were a number of early plastic materials, moulded into attractive designs.

Despite their low price, cartes from the well established studios were not considered to be inferior to the daguerreotype or ambrotype, as many historians assume them to be. The *carte de visite* was a format like any other, considered to be worthy of the same sort of quality presentation afforded to the earlier processes. Thus cartes were often packaged in leather cases or mounted in ornate frames to meet the customer's demands.

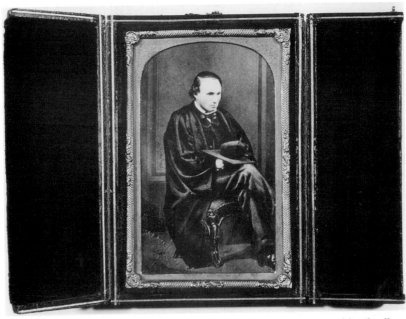

The carte de visite was not always relegated to the obscurity of the closed family album, nor was it always framed and placed on public display. For the customer who wished to endow the carte with the same degree of exclusivity as had hitherto been enjoyed by the daguerreotype and ambrotype, leather cases were available in a range of styles. This example, of a university graduate, is by Hill & Saunders of Oxford, c.1870.

For the family who wanted something a little richer than the simple family album, elaborate moulded thermoplastic covers were available, often with a monogram engraved on to the face. This example dates from c.1880.

The ultimate in leather cases for ambrotypes, this quarter plate case is decorated with a scroll and urn design in gold leaf.

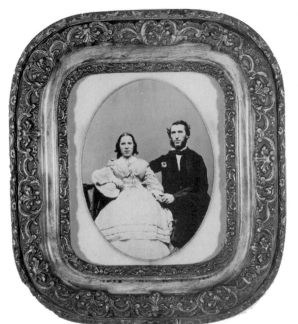

Frames for daguerreo-types, ambrotypes and cartes de visite came in a wide variety of styles and sizes. This example is in wood and painted plaster and houses a half plate ambrotype c.1865.

A pressed metal frame, made in France c.1860, for a sixth plate ambrotype.

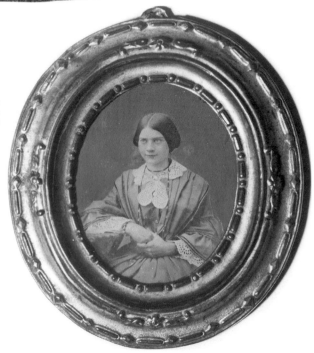

A painted carved wood frame from about 1860, housing a fine ambrotype of a seated gentleman.

This larger pressed metal frame houses a sixth plate ambrotype, surrounded by a gilt and cream matt.

Top left: *Thermoplastic union case, carte de visite size, made c.1860 by John Smith of Birmingham. As far as research has been able to confirm, John Smith seems to have been the only British manufacturer of union cases, a predominantly American product. Smith produced several case designs for the carte de visite, suggesting that despite its low cost, the small card-mounted paper print was accorded greater importance in its early days than is often assumed. Smith produced two different sizes of carte cases. Many photographers produced ambrotypes and tintypes to fit this format as well.*

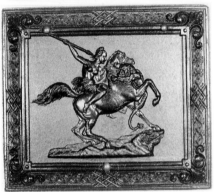

Top right: *'Bobby Shafto', a sixth plate union case manufactured by A. P. Critchlow & Company; engraver unknown. Several union case designs celebrated children's rhymes, suggesting that they were intended for child portraits. Critchlow was one of the major American manufacturers of these cases.*

Centre: *'Amazon on Horseback Being Attacked by a Tiger', a ninth plate thermoplastic case by John Smith of Birmingham. The design is based on a full-size bronze sculpture by Auguste Kiss, which was one of the most popular attractions of the Great Exhibition at the Crystal Palace in 1851.*

Bottom: *'The Voyage of Life – The Family', a sixth plate union case, engraved by Frederick Seiler; casemaker unknown. This is one of several cases probably inspired by – but not copied from – a series of paintings by Thomas Cole. Others in the series included 'The Launching', 'Youth – Love' and 'Old Age'.*

As a format, the *carte de visite* size was available in ambrotypes and later in tintypes, and several examples of carte-sized ambrotypes have been found in thermoplastic union cases, the packaging product with which the presentation of the Victorian photographic portrait reached the pinnacle of its technological and artistic achievement.

The union case first appeared about 1853, the product of Samuel Peck & Company of New Haven, Connecticut, in the United States. By the time its popularity eventually died out, over one thousand designs of union case had been produced and marketed. Despite the huge numbers of different designs which have been identified, they were produced by a very small number of companies. So far, only one British maker has been identified.

The British manufacturer was John Smith, a maker of 'horn buttons' in the Midlands, who took out two patents, in 1859 and 1860, for the manufacture of thermoplastic items including union cases. Horn buttons were actually made of an early thermoplastic. Indeed, in a number of British advertisements for union cases, both British and American, the cases are described as 'horn cases' or 'horn union cases' rather than the accepted American term of 'thermoplastic union cases'. Smith's entry into the plastic market was some six or seven years after Peck had

Below left: *Oval union case, sixth plate case, by Littlefield, Parsons & Company, c.1860. The glass plate ambrotypes which were fitted into these cases were hand-trimmed to oval.*
Below right: *'Morning', a quarter plate union case manufactured by John Smith of Birmingham c.1860, engraved by Brookes & Adams, also of Birmingham. The design is based on 'Day, Aurora with the Genius of Light' by the Danish sculptor Bertel Thorvaldsen, and this case is one of three variants on Thorvaldsen's original bas-relief which were produced by Smith in the early 1860s.*

pioneered photographic portrait cases, and at least five years after the cases first became commercially available in Britain.

Smith's patents are very different from those of his American rivals, for while the American patents cover such aspects as the design of the hinges or the spring closures, Smith's patents cover the composition of the thermoplastic material from which the cases were manufactured. As the recipe for the shellac-based thermoplastic was considered to be in the 'public domain' in the United States, none of the major manufacturers sought to patent it, but there were no patents for union cases registered in Britain, so Smith was quite within his rights to patent both

Above left: *'Birds at the Fountain', ninth plate thermoplastic union case, late 1850s, by Samuel Peck & Company. Like many other designs, this motif inspired casemakers working in leather and papier-mâché, as well as thermoplastic. Simple themes like this lent themselves to a wide variety of interpretations and offered individual casemakers and die engravers the opportunity to exploit the commercial potential of popular ideas from nature, art and mythology.*
Above right: *'Cupid in a Rose', another ninth plate union case which shares a design with an earlier leather case. This design is also from Samuel Peck & Company.*
Leather variants on both these themes are illustrated on page 93. In plastic, there were at least two sixth plate variants on the 'Birds at the Fountain', and two ninth plate. No other variants on 'Cupid in a Rose' have so far been located. In leather, examples of both the above designs have been found in both sixth plate and quarter plate.

the material and its application. His patent was detailed:

'I, John Smith, of Birmingham in the County of Warwick, Manufacturer, do hereby declare the nature of the said Invention for "Improvements in the Manufacture of Composition Jewellery and Ornaments, and of Cases for Jewellery, Photographs, and for other similar Purposes", to be as follows, that is to say:–

My invention consists in the production of articles of the above description from a composition or plastic compound not hitherto used for that purpose, and in the process of preparing the said composition.

The composition consists of shell-lac, ebony dust, and charcoal for a

Above left: *A slim-profile carte de visite case of geometric design by John Smith. Only Smith in Britain and Samuel Peck (and his successors the Scovill Manufacturing Company) in the United States seem to have made inroads into the carte de visite case market, although, as a number of cases have been located without a maker's label inside them, other manufacturers may yet be identified.*
Above right: *'The Music Lesson', a quarter plate union case by Littlefield, Parsons & Company. This is one of a number of quarter plate and sixth plate cases employing the simple motif of a family enjoying making music. The engraver was A. Schaefer, whose name appears on a number of cases. This case, while sold in the United States with a Littlefield, Parsons & Company label attached, was marketed in Britain with a label proclaiming the 'Patent American Union Case'. Research suggests that the 'patent American' labels may have been inserted by Elisha Mander of Birmingham to market imported cases. The 'American' association was seen as an assurance of quality in the plastic case market.*

black composition

If coloured composition articles be required, the charcoal must be omitted or reduced in quantity, and any suitable colouring matter, such as powdered pigments, must be added.

The process of making the composition and subsequently manufac-turing it into the articles already named is as follows:– I take one pound of shell-lac and dissolve it by heat on a flat iron slab; I then mix with it an equal quantity by bulk of ebony dust, produced either by sawing, turning, pulverisation, or otherwise, after which I add the colouring matter

The whole of the ingredients having been well mixed upon the slab and upon a heated stove, lumps of sufficient size are to be taken and placed in dies of any description suitably designed for the form of the articles intended to be produced, and each die with its follower being then removed to a press, the press may be of the kind ordinarily used by the manufacturers of horn buttons; the article is completed by pressure. The composition readily cools by contact with the dies, so that the article in a finished state may be almost immediately removed from the dies. In manufacturing double-sided articles such as the cases alluded to in my title, each shell or side is moulded separately, and afterwards suitably connected by hinges or rivets . . . '

Smith is also unique amongst plastic case makers in including his name in one of his designs – a variant on the 'Morning' design illus-trated on page 105 bears the legend 'Smith's Patent 1860', making it also the only case to bear a date.

With the union case, the packaging of the photographic portrait reached its peak of sophistication. The Victorians, always impressed by techno-logical and manufacturing innovation and progress, must have revelled in the marvel of photography being packaged in the new moulded plas-tics. Both photography itself and the manufacture of plastic cases were seen as the perfect marriage of art and science.

The moulds were not particularly robust, so production runs of these remarkable cases cannot have been large. How many different designs were marketed may never be known, but collectors are still finding new and hitherto unknown designs.

Union cases ceased to be manufactured after the mid 1860s. The designs used on many quarter plate and half plate cases enjoyed a few further years of popularity as lids for collar boxes and jewel cases, but the plastic photographic case had largely disappeared by 1870.

Thermoplastic went on to be used for a variety of frames, album covers and photographic brooches and other jewellery, before largely disappearing from the market in the 1880s. By 1890, with professional photography priced within most people's pocket, and the dawn of mass

'Money Musk' or 'The Country Dance', a quarter plate union case by Littlefield Parsons & Company, late 1850s.

'Cupid and the Wounded Stag', a quarter plate union case by Samuel Peck & Company, mid 1850s. Variants on this theme were also used on several sixth plate cases.

amateur photography on the horizon, the photographic portrait was no longer considered to be the treasured icon it had been since its introduction half a century earlier.

The family album, containing both *cartes de visite* and the larger cabinet prints, together with tiny tintypes, survived well into the twentieth

century in most homes, but in a less elaborate form. Late Victorian and early Edwardian albums often lacked the elaborate decoration of their predecessors. They tended to be mass-produced from cheaper materials in order to keep unit cost down.

It is understandable that, as photography became more commonplace and less expensive, public and personal perceptions of the individual image would change. The photographic portrait was no longer unusual, no longer a novel innovation and no longer exclusive.With millions of images being made every year all over the world, the consideration afforded to any individual portrait was reflected in the expense of its packaging.

From its introduction in the 1840s, the packaging and presentation of the portrait had accounted for a significant portion of its cost. With *cartes de visite* cased in expensive thermoplastic, that proportion briefly and untypically rose, after years of decline. As photography began to move from a passive activity to an active one – from being photographed to taking photographs oneself – public attitudes changed completely.

Towards mass production

'My instructions hitherto have been limited strictly to the chemical and mechanical manipulations that occur in that department of photography dominated by the Wet Collodion Process. This process will ever remain the predominant mode of conducting photographic operations in the room; it is preferred, too, by many tourists in the field. The inconvenience, however, of dragging along over mountain and valley, or of stowing away on steamer or on the cars, a complete miniature operating gallery, has suggested the idea of superseding all this trouble by the discovery of a dry process.'

Thus did Professor John Towler MD, in his book *The Silver Sunbeam* in 1864, make the common error of writers who believe they can foresee the future: he believed wet collodion would forever be the process favoured by photographers. Had he been right, photography would never have become the universal medium it is today.

Despite the obvious advantages of the wet collodion process in terms of its sharpness, its speed and its ease of printing, the need to have the coating and processing facility close by was an enormous drawback and burden. Many workers sought out ways of being able to prepare the collodion plates at home and use them over the following few days.

The most interesting was the coating of the prepared wet plate with hygroscopic chemicals designed to attract moisture to the coating, thus keeping it moist and sensitive. The idea was proposed by, amongst others, the Frenchman Marc Gaudin and the British chemist Sir William Crookes. In partnership with a fellow photographer, John Spiller, Crookes also pioneered the idea of treating the prepared plate with magnesium nitrate, which acted as a preservative and extended its life by almost a week. Other workers suggested an assortment of preservatives, or coating the plate with gelatine to seal the collodion emulsion in.

The real future of photography lay in dry plates, and the development of dry processes on glass did not follow wet collodion but actually preceded that process.

Although its success was limited, the first true dry process on glass was the albumen-on-glass process invented by Claude Felix Abel Niépce de St Victor as early as 1847, and made public the following year. The process involved coating glass with a mixture of egg-white, potassium bromide and potassium iodide, which was then sensitised with acidified silver nitrate. When dry, the very thin, and extremely slow, plates were exposed to produce some very fine grain negatives, developed in gallic acid. But the exposure of fifteen to twenty minutes even on a bright day meant that the process was less than ideally suited for action photography. All the endeavours of the 1850s and later were designed to pro-

Briggate, Leeds: lantern slide published in the 1870s by James Valentine's studio in Dundee. It is unlikely that James Valentine would have taken the picture himself, as images like this, shown here at 1¹/₂ times actual size, were usually purchased locally from photographers. Although taken when the (much slower) dry plate processes were gaining popularity, the short exposure necessary to freeze all the action and detail in the scene suggests that wet collodion was used to take this image.

duce a dry plate with a worthwhile sensitivity.

This first dry glass process gave the photographer as much preparatory work to do as the wet plate did and in some respects was even more difficult to master. Some photographers are reported to have found even the notoriously difficult waxed paper process easy after trying

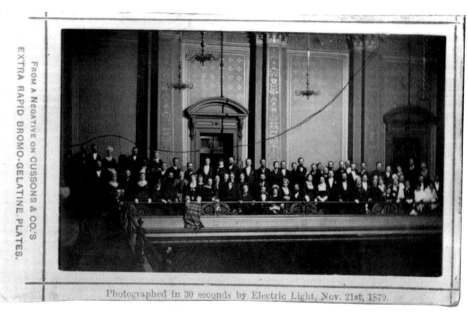

The printed caption on this carte de visite celebrates the fact that the image was made on Cussons Extra Rapid Bromo-Gelatine dry plates, on 21st November 1879, with an exposure of thirty seconds, illuminated by electric light, but it omits to mention what the occasion was which brought the subject group together. Whatever the event, the twin achievements of photography indoors with a dry plate and photography by electric light mark the progress dry plates had made by 1879.

albumen-on-glass.

Many were highly complimentary about it, though, and committed to mastering its intricacies, taking steps to ensure its consistent quality. The photographer J. E. Mayall was very particular in his instructions to fellow photographers as to how the preparation of albumen plates ought to be approached:

'The eggs must be fresh, not more than five days old. They ought to be kept in a cool place. Those from the country are better than town-laid eggs, and I advise, where practicable, that the hens should have car-bonate and phosphate of lime to peck at. This enriches the albumen and renders it more limpid. Each egg must be broken separately into a shallow cup, and the yolk retained in the shell as well as the germ; then poured into a measure until the required quantity of limpid albumen is obtained.'

Mayall did not offer suggestions as to how the photographer might check the history of the hens' diet! The demand for egg-whites, both for the albumen-on-glass negative process and, more particularly, for the

Four composite cartes de visite by Francis Bedford, late 1860s. The original views were taken with collodion wet plates or albumen dry plates, and the large contact prints were pasted on to a pre-printed board before being rephotographed on albumen-on-glass.

huge amounts of albumen printing paper which were required, caused a huge increase in the quantity of eggs used in photography. With such large quantities of egg-white being used to manufacture photographic materials, there was even a 'photographers' cookbook' which used only the yolks!

In the manufacture of albumen dry plates, the fresh albumen was combined with a saturated and slightly caustic solution of iodide and bromide in distilled water, and after mixing (carefully, to avoid introducing air bubbles) was allowed to stand in a darkened room for several hours. Then came the complex coating process, a process which in total took five days. First, the albumen mixture was poured on to the plate, and the excess brushed, sponged or blotted off. The coated plate then had to lie absolutely flat in a plate box for the three days on average it took for the coating to dry. In this state, the plates were thought to keep indefinitely, but serious workers made a month's supply at a time.

Sensitising, by immersion in silver nitrate, was followed by draining and drying in a second plate box. This time the plate had to be kept vertical to ensure that all the excess chemicals drained off.

Albumen plates could be exposed damp, giving a huge increase in speed, but those who best exploited the operational benefits of the process preferred the dry version. When the plates were used dry, coating could be carried out two or three weeks before use, and development several weeks afterwards.

The results produced with the process were good, but there were considerable advantages of combining albumen and collodion, and the first wholly successful example of this, Taupenot's collodio-albumen process, was introduced as early as 1855 and popularised by several leading landscape and architectural photographers.

Despite great claims made for each of the early dry processes in turn as they were introduced, their real value can be judged by remembering that the wet collodion plate remained supreme for many years thereafter.

The best-known commercially produced early dry plate, developed by Dr Hill Norris of Birmingham, was patented as early as 1856. Other developments followed with considerable rapidity, changing photography forever and laying the foundations of the range of materials we enjoy today.

The production of the light-sensitive materials became the domain of the specialist manufacturer, one of the first being Hill Norris's Patent Dry Collodion Company, later known as the Birmingham Dry Collodion Plate and Film Company Limited.

Another innovator in the evolution of dry collodion was the Liverpool Dry Plate Company, launched in 1867 by W. B. Bolton and B. J. Sayce,

York Minster from the south-west, published by Francis Frith. The number of albumen prints which were produced by the Frith publishing company in Reigate must have been enormous. Many bear the blindstamp legend 'Frith's Series' and date from the 1860s and 1870s.

to market their plates. As an alternative to the silver nitrate used by Hill Norris and others, Bolton and Sayce used an emulsion of silver bromide in collodion, producing a plate which was much slower than its rivals but had excellent keeping qualities. It was potassium bromide in gelatine rather than dry collodion which was successful in starting the mass production of photographic materials in the 1870s.

The dry plate's singular contribution to Victorian photography was eventually to redefine the central purpose of the darkroom. Previously the darkroom had been the place where photographic materials were

Cheddar Gorge, also from Frith's Series, c.1870. Note the use of what is probably the photographer's carriage to give scale to the picture.

manufactured before exposure and then processed afterwards. With the advent of dry plates, the darkroom became no more than the processing area.

Instead of the darktent, or whatever other light-safe enclosure the wet collodion photographer used on location, the photographer armed with dry plates carried either a large plate box, with a changing facility, or a number of pre-loaded darkslides. Either way, the total weight of the equipment which had to be carried was substantially reduced, but in those early days so would have been the photographic opportunities.

The photographer working with slow early dry plates needed still weather and still subjects.

As the majority of photographers used Blanquart-Evrard's albumen printing-out paper, which was exposed outdoors in natural light by contact with the original plate, the darkroom of a photographer using commercial dry plates became a less used facility than it had been in the wet plate era. No longer were all the paraphernalia of the coating process needed. Instead, a simple darkened room in which the exposed plate was developed was all that was necessary.

While all these advances were taking place in the evolution of the negative material, albumenised printing paper, introduced in 1850, had established itself as the standard printing material. It was finely detailed, had a very smooth finish and, when gold-toned, produced a permanent and sumptuous print, as evidenced by the huge numbers which have survived to this day in exceptional condition. The manufacture of albumen paper was at the forefront of the move towards mass production of photographic materials.

Despite its many qualities, albumen paper did have drawbacks, not the least of which was the need to sensitise and then dry the paper before use. In its commercial form, albumen paper was usually sold in a partially manufactured state, coated with the albumen layer which carried a suspension of common salt (sodium chloride) but not yet sensitised. Once passed through a silver nitrate bath, creating the light-sensitive silver chloride layer, and then dried, the paper was ready for use but had a relatively short life before its sensitivity became unreliable. The printing speed could be increased by passing the sensitised albumen paper, while still wet, over a bath of ammonia immediately after taking it out of the nitrate bath. When fully manufactured and ready-to-use albumen papers were introduced in a limited way in the 1860s, they had a shelf life of about one week.

The norm was for the paper to be exposed until the required image strength was achieved by the action of light alone. Rarely were these prints developed. Blanquart-Evrard pioneered a developed version of Talbot's salt print in the early 1850s, aimed predominantly at the growing number of books which were being illustrated with real photographs. As the developed print could be produced after a much shorter exposure, and at the rate of hundreds per day instead of the half dozen or so which were possible using albumen, the process achieved some measure of success. More significantly, it pointed the way for the future of printing.

Despite its undoubted popularity, the albumen print, laden with silver nitrate and producing a print-out image, was difficult to manipulate, and even more difficult to modify. The future lay in bromide-rich

Right: *Thomas Rendl as Pontius Pilate, from the 1880 Oberammergau Passion Play, photographed by B. Johannes of Partenkirchen, Bavaria. A commercially produced set of portraits and scenes from the play was marketed after each production.*

PASSIONSPIEL OBERAMMERGAU 1880

PILATUS THOMAS RENDL.

emulsions which could combine short exposure, short development and maximum user control.

Photographers turned their backs on eggs and started instead to demand huge quantities of crushed animal bones for making gelatine, and the demand for eggs subsided considerably as gelatine gained supremacy.

When gelatine dry plates, and papers coated with gelatine emulsions, first made their appearances, they were, not surprisingly, much more expensive than their home-made counterparts. It was only with the introduction in the 1880s of coating machines able to coat rolls of paper that gelatine emulsion technology started to gain momentum. Quality and consistency improved, prices came down, and the foundations of today's paper industry were laid.

Dr Richard Maddox's gelatine dry plates first became available in

1871 and were in mass production by 1873, the same year that the Liverpool Dry Plate Company, itself a pioneer of dry plates with their dry collodion plates in 1867, introduced the first examples of gelatine-bromide papers.

As well as introducing both amateur and professional photographers to the concept of the developed print, it was the introduction of bromide paper which brought exposures down to a level where artificial light could be used as an exposing source. Hitherto, only bright daylight had been a practical proposition, severely limiting printing to bright and dry days.

Identifying the different types of prints is relatively straightforward, for each type of printing paper had its own very obvious characteristics. Albumen prints, for example, never have whites because the cream base colour meant that the un-toned print was a rather sombre-looking production. Once the print was gold-toned, however, the deep rich purple browns of the image itself went a long way towards overcoming any flatness in the highlights which the high minimum density might have produced. Gelatine bromide papers had, from their introduction, much cleaner whites and much richer blacks, but with a less subtle tonal gradation between those extremes. Also from their introduction, they offered a higher gloss finish to photographs than had been possible with albumen. Albumen paper had an extremely long tonal range, giving a subtlety to the mid tones and the shadows which today's papers cannot reproduce.

If there was a specific difference between albumen paper and today's bromides, it was the fact that, as with all printing-out papers where the exposure was long enough to produce the image by the action of light alone, the contrast of an albumen print could not be easily modified.

Moving to developed prints gave photographers the chance to effect some contrast control in development. So low-contrast albumen prints are low-contrast simply because of the light quality during the exposure of the negative, or because of contrast changes effected during development of the collodion negatives.

By the 1870s, with the increasing use of dye sensitisers to extend the sensitivity of dry collodion plates beyond the blue to which materials had been restricted since photography's discovery, the photographic print began to reflect more accurately in monochrome the tonal relationships evident in nature.

By the 1880s, as the manufacture and marketing of dry plates and of developed printing papers increased substantially, costs were dropping and the number of people taking up photography as an absorbing hobby was also increasing sharply.

Smaller plates and faster papers changed photography for ever. No

longer did the negative have to be the same size as the required print. In 1884 the Britannia Works Company, the forerunner of Ilford Limited, introduced Rapid Bromide papers, capable of being exposed by artificial light in an enlarger.

The well-established whole plate size became less popular than the quarter plate, as the reduced weight of the quarter plate camera made for greater portability. The reason why the half plate size is larger than two quarters, and more than half the size of the whole plate size, is the need to maintain the aspect ratio. Thus quarter, half and whole plate sizes all had an aspect ratio of approximately 4:3.

With daylight no longer the only possible exposing source, a range of alternatives appeared on the market. Gaslight was a rapidly growing source of domestic illumination, and 'gaslight paper', a slow silver chloride or chloro-bromide paper, was an early introduction, and one which survived well into the 1950s.

Acetylene lighting, carbon arcs and electricity were all employed in early enlargers, adding significantly to what could be achieved in the darkroom, but also adding to the risk. Having got rid of the problems of the ether in collodion, the photographer was now confronted with noxious fumes from burning light sources, or the attendant risks of unearthed electricity.

The greatest revolution, however, was in camera design and in the materials the camera contained. With the introduction of the first 'Kodak' camera in 1888, George Eastman set photography on a revolutionary course. The hundred-shot Kodak No. 1 used stripping film, with the negatives being stripped off their paper base on to a transparent base for printing. By the end of 1889, however, film, as we know it today, had been introduced.

In an early advertisement for the Kodak camera, it was claimed that: *'Anybody can use the Kodak. The operation of making a picture consists simply of pressing a button. One hundred instantaneous pictures are made without re-loading. No darkroom or chemicals are necessary. A division of labour is offered, whereby all the work of finishing the pictures is done at the factory, where the camera can be sent to be reloaded. The operator need not learn anything about photography. He can "press the button" – we do the rest.'*

Of course, not all photographers wanted to hand all the finishing work over to the factory.

What the introduction of the Kodak camera did achieve was to give the photographer a choice. Hitherto photographers all had to process their pictures themselves; now they could choose whether or not to do so. That choice was just as validly exercised in deciding

to process and print as in deciding not to.

George Eastman, writing in the first edition of his booklet *The Kodak Primer*, asked: *'Will any sane man or woman (for there are thousands of lady votaries of the photographic art) maintain that the necessity of going through ten specific operations, the omission of any one of which would irrevocably spoil the work, does not seriously detract from what would otherwise be a delightful pastime?'*

He wrote that in marketing the camera, he sought to *'furnish anybody, man, woman or child, who has sufficient intelligence to point a box straight and press a button'* with a camera so simple that it *'altogether removes from the practice of photography the necessity for exceptional facilities, or, in fact, any special knowledge of the art.'*

Eastman's vision of photography was far removed from the world into which he introduced his Kodak camera. Given that most photography was executed on sheets of glass, in bulky cameras, by photographers who spent much of their lives in near darkness developing and printing, this approach to photography was revolutionary.

It was not completely new, though, for roll-holders had been introduced in the 1850s for long rolls of waxed paper, and magazine cameras had been around for decades. But the concept of sending everything away to be processed was uniquely George Eastman's. At five guineas (£5.25) for the camera, and two guineas for processing, the cost was huge – far from the working class photographic revolution it has often been presented as. That came about much later once prices dropped dramatically. Initially, Eastman's Kodak No. 1 camera was a luxury, a plaything for the very wealthy.

In the late 1990s many laboratories will develop and print up to twenty-seven frames for £1.99. At that price, today's photographer could get seventy pictures processed and printed – in colour – for five guineas. In 1888 12s 6d (62p) was an average weekly wage. A Victorian worker would have had to work for almost four weeks to earn enough to pay the processing and reloading costs of one hundred pictures, whereas today's amateur would work for about fifty-five minutes. Using wage comparisons to give a true idea of the cost of the camera, a camera with a cost price relative to the five guinea Kodak No. 1 would today cost well over £2000.

By the middle of the 1890s the cost of the camera had decreased to one guinea, with a slightly less dramatic drop in processing costs. It would be well into the twentieth century before photography became cheap.

The 1880s and 1890s were of pivotal importance in the evolution of

A working class snapshot taken outside a terraced house in Plymouth in the 1890s. The original Kodak cameras took circular pictures, one hundred per roll, with each picture measuring 63 mm in diameter. Later, cameras producing 75 mm diameter images were introduced. Both the images on this page come from the larger size and are reproduced at 20 per cent larger than actual size.

No. 2 Kodak camera snapshot taken by the river Dochart in Scotland, 1890s.

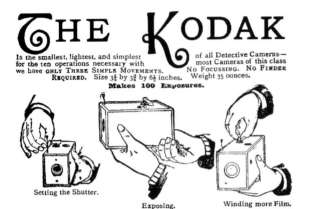

⒢HE ⒦ODAK

Is the smallest, lightest, and simplest
for the ten operations necessary with
we have ONLY THREE SIMPLE MOVEMENTS.
REQUIRED. Size 3¼ by 3¾ by 6½ inches.
Makes 100 Exposures.

of all Detective Cameras—
most Cameras of this class
NO FOCUSSING. NO FINDER
Weight 35 ounces.

Setting the Shutter.

Exposing.

Winding more Film.

*The instructions for
the Kodak camera
described its opera-
tion by means of a
simple series of
drawings.*

*The Kodak camera was little more
than a box, with a simple meniscus
lens at the front, of fixed focus and
with a fixed aperture. When the hun-
dred exposures had been made, the
camera was returned to Kodak for
processing and reloading with fresh
film. Until prices dropped during
the 1890s, using a Kodak was a rich
man's pleasure.*

the medium. As photography, both amateur and professional, moved
into mass-produced materials, systems were evolved to ensure consist-
ency and standardisation.

The establishment of commercially agreed film sizes, allowing pho-
tographers to use any maker's materials – something taken for granted
today – was one of the more crucial. But the emergence of commercial
materials manufacturers also brought with it the introduction of compe-
tition. What better selling point could there be than the claim that manu-
facturer A's plates were much more sensitive than those of manufac-
turer B? That the 'faster' plates required hugely increased development
was underplayed in their promotional material by some less scrupulous
manufacturers. Ferdinand Hurter and Vero Driffield, two scientists,
were determined to establish a sound scientific basis for the compara-
tive assessment of emulsion sensitivity. Their work was crucial in lay-

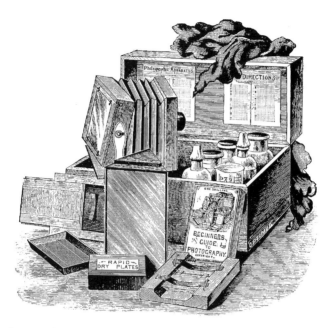

For the photographer who eschewed the simplicity of the Kodak approach to photography, compact dry plate outfits were available. This outfit contains a quarter plate camera, darkslides, 'rapid dry plates', a 'Beginner's Guide to Photography' and all the dishes and chemicals necessary to develop the plates at home. On top of the open camera case is the black cloth which covered the photographer's head as he or she focused the camera. Compare this with the simplicity of the Kodak camera opposite, and the complexity of the early wet plate outfits discussed earlier.

ing down a basic understanding of how photographic emulsions respond to both exposure and processing, and in establishing public recognition of the value of having a single set of measures through which to define sensitivity or 'speed'. Through their researches, Hurter and Driffield sought to establish a sensitivity measure which was independent of processing, so that plates could be given the optimum exposure in the camera and the shortest effective development in the darkroom to yield maximum information on the negative.

Until the advent of mass production of materials, plate speed systems were irrelevant. As every photographer made his or her own materials, with all the expected variation from one batch to the next, such sophistication was unnecessary. For users of the Kodak camera, always reloaded with the same consistent product, emulsion speeds were still an irrelevance, and in that respect Eastman did amateur photographers

an immense service. He gave them reliability of material and exposure without them needing to know anything of either.

For those who still enjoyed the pleasures of home developing and printing, if no longer the dubious pleasure of coating their materials at home as well, a little more technical and chemical understanding was needed. They could, if they wished, cut the film in the Kodak camera and develop and print that at home. In that way, images could be developed and printed before all hundred exposures had been made.

Hurter and Driffield were not photographers: they were industrial chemists. Their work was directed towards establishing industrial standards, rather than any altruistic endeavour to help photographers. Their H&D speed system, however, was perhaps the single most important milestone along the road to the reliable and sophisticated speed systems which are enjoyed today. Before the publication of plate speed tables there were no simple exposure meters, no accurate processing times, and an almost universal lack of understanding of the relationship between exposure, development and tonal range. The science of sensitometry (the study of how photographic materials respond to exposure and processing) is Hurter and Driffield's legacy to today's high-quality photographic materials.

Having carried out extensive experiments, Hurter and Driffield observed that every material had an inertia level, an amount of exposure which resulted in no perceptible density in the developed plate. It was only when inertia was overcome that a density due entirely to exposure was achieved. Any other density, they argued, was an inherent fog level in the material itself or was the result of the development process. Thus they had a basic mechanism for separating measurable density caused by exposure from measurable density caused by other factors. In practical terms, that meant that plate makers who claimed high speeds for their plates but achieved them only after prolonged development would be found out. By today's sophisticated speed standards, the H&D system was crude and flawed but it was the first serious attempt at tackling a huge problem.

Getting agreement to adopt such a set of standards was not easy, especially given that it effectively outlawed unscrupulous claims for material speeds, but Hurter and Driffield persevered. Their speed system was published in 1890 and, gradually over the following decade, more and more manufacturers sought credibility for their materials by citing H&D speed ratings for them. There was no single moment when everyone adopted the system, and indeed there were 'rival' speed systems in use at the same time. What was important, though, was that the speed of any material was understood to be relative to others in the market place, and to have been arrived at by adopting exposure and

Blackpool Beach, 1890s. This image is reproduced from a coloured 'Photochrome' print, a popular tourist purchase from about 1896.

processing practices designed to approach the perfect negative. Photography was adopting standards.

As the century, and Victoria's reign, drew to a close, what the Queen had once described as the 'black art' of photography reached the end of an era. From Joseph Nicéphore Niépce's first eight-hour exposure in the 1820s – so long that the sun is shining from both sides of the picture – photography had travelled a remarkable distance by the end of the century.

As the century closed, the necessity for transporting portable dark-rooms and supplies of distilled water wherever photography was being undertaken was already a generation in the past. Exposures which had still been counted in seconds in the 1860s and 1870s were counted in fractions of a second by 1890. Photographers now required the sophis-

'Koh-i-Noor' seen off Clacton, fully laden! This 'Photochrome' print has a serial number: 10,257. The company marketed what they claimed were 'views by colour photography' throughout Europe but they were in fact carefully coloured monochrome views. The possibility of colour photography had been demonstrated by James Clerk Maxwell as early as the 1860s, but it was the closing years of the nineteenth century before the first successes were registered. John Joly in Dublin produced crude additive colour transparencies using a series of red, green and blue lines, but they were not very convincing. Not until 1908 did the first successful colour process go on sale: the Autochrome invented by the Frenchmen Auguste and Louis Lumière.

tication of timed shutters. The Thornton-Pickard 'Time and Instant' cord-pull shutter, the mainstay of many a photographer's outfit, started to appear on cameras in 1892.

The 1890s also saw practical colour photography come a step closer, and within the first few years of the twentieth century Auguste and Louis Lumière in France would market the Autochrome colour plate. As the nineteenth century closed, those same Lumière brothers were starting to achieve some success with motion pictures, where each frame was exposed for a mere fraction of a second. Photography's 'modern' era was starting with a new century.

The Prince of Wales arriving in Wigan, Lancashire, for an official visit in 1897. Four years later he became King Edward VII. Local photographers captured the royal visit with large gelatine dry plates.

Places to visit

Almost every museum makes some reference to photography, so important is the medium in our understanding of Victorian history.

The premier museum is the **National Museum of Photography, Film and Television**, Pictureville, Bradford, West Yorkshire BD1 1NQ (telephone: 01274 727488), with several floors of interactive exhibits, and a programme of exhibitions in its several galleries. This huge museum manages to combine a good historical presentation of photography's past with a hands-on introduction to present-day imaging systems.

Researchers will find the museum's specialist staff especially helpful, ready and able to answer questions on a wide range of subjects. It includes the former Science Museum collection from London, and the Kodak Museum collection, as well as many other important collections, and has been described as the most successful photographic museum in the world.

After visitors have looked at the exhibitions, there is also the IMAX cinema to visit, with Britain's largest cinema screen. *(The museum is closed for renovation until 1999.)*

The **Royal Photographic Society**, Milsom Street, Bath, Somerset BA1 1DN (telephone: 01225 462841), has a permanent exhibition on the early years of photography and also presents occasional historical exhibitions drawn from the Society's magnificent permanent collection.

The **Photographers Gallery**, 5 Great Newport Street, London WC2H 7HY (telephone: 0171-831 1772), also mounts occasional historical exhibitions, although the majority of its shows are contemporary. Exhibitions are also occasionally held at the **Museum of London**, London Wall, London EC2Y 5HN (telephone: 0171-600 3699), the **Victoria and Albert Museum**, Cromwell Road, South Kensington, London SW7 2RL (telephone: 0171-938 8500), and the **National Portrait Gallery**, St Martin's Place, London WC2H 0HE (telephone: 0171-306 0055).

In Scotland, the **Scottish National Portrait Gallery**, 1 Queen Street, Edinburgh EH1 2NG (telephone: 0131-556 8921), presents major photographic exhibitions and is also home to the Scottish Photography Archive.

The **Fox Talbot Museum**, Lacock Abbey Barn, Lacock, near Chippenham, Wiltshire SN15 2LG (telephone: 01249 730459), is housed in the barn at Talbot's Wiltshire home and contains exhibits specific to

Fox Talbot and the evolution of the calotype, as well as periodic exhibitions, both of other calotype users and of more contemporary work. Talbot's house, Lacock Abbey itself with the famous lattice window he used as the subject for his first successful camera negative, is owned by the National Trust and is also open to the public.

Also worth a visit are: the **Science Museum** (Photography and Cinematography Galleries), Exhibition Road, South Kensington, London SW7 2DD (telephone: 0171-938 8000), and the **Sutcliffe Gallery**, 1 Flowergate, Whitby, North Yorkshire YO21 3BA (telephone: 01947 602239).

Information sources

Books on early photography

Channing, Norman, and Dunn, Mike. *British Camera Makers*. Parkland Design, 1996. The story of British-built cameras from Fox Talbot to the immediate post-war years; the most comprehensive review of British cameras yet written.

Coe, Brian. *The Birth of Photography*. Ash & Grant, 1976. Long out of print, this introduction to the history of photography is still an enlightening read despite its date. Local libraries should still have a copy.

Coe, Brian, and Gates, Paul. *The Snapshot Photograph*. Ash & Grant, 1977. Coe was curator of the Kodak Museum when he wrote this book on the birth of the amateur snapshot photograph.

Crawford, William. *The Keepers of Light*. Morgan & Morgan, 1979. This fascinating book combines an easy to read introduction to the history of photography with a series of fascinating step-by-step accounts of how to make many of the historical processes work today.

Gernsheim, Helmut. *The Origins of Photography*. Thames & Hudson, 1982. Revised, updated and extensively rewritten from the first part of Gernsheim's 1955 classic history of photography, this book deals with some of photography's prehistory and with the invention and popularisation of both the daguerreotype and the calotype.

Gernsheim, Helmut. *The Rise of Photography*. Thames & Hudson, 1988. The second part of the revised history of photography, this book is a revealing account of the growth of photography during the collodion era.

Hannavy, John. *Fox Talbot*. Shire, third edition, 1997. Extensively rewritten and re-illustrated for its third edition, this Shire Lifelines title offers an accessible introduction to the life and work of the man often referred to as the 'father of modern photography'.

Turner, Peter. *History of Photography*. Bison Books, 1987. This book abandons the standard chronological structure for a thematic image-based approach. Despite some limitations, it thus presents a fresher and more visually articulate introduction to the subject.

White, Robert. *Discovering Old Cameras 1839-1939*. Shire, third edi-

tion, 1995. White's classic pocket guide to early cameras offers a good insight into the range of camera designs, format and types in photography's early years. In 1995 it was joined by a second volume covering cameras from 1945 to 1965. Both are essential for the collector.

Societies dedicated to early photographic images and equipment

The Photographic Collectors Club of Great Britain (PCCGB), 5 Station Industrial Estate, Low Prudhoe, Northumberland NE42 6NP. The club holds meeting throughout Britain, organises regional collectors' fairs throughout the year, and one national fair, Photographica, each spring in London. A quarterly newsletter, containing a postal auction, and a quarterly glossy journal, *Photographica World,* are sent to all members.

The Royal Photographic Society, The Octagon, Milsom Street, Bath, Somerset BA1 1DN. This is one the oldest and most prestigious photographic societies in the world. It has a number of specialist groups, one of which is the Historical Group, dedicated to all aspects of photography's history. All society members receive *The Photographic Journal* ten times a year – a journal which has been published continuously since 1853. Members of the Historical Group, which organises a regular programme of lectures in London and occasionally elsewhere, additionally receive the quarterly *Photo-Historian.*

The Daguerreian Society, 3045 West Liberty Avenue, Suite 7, Pittsburgh, Pennsylvania 15216-2460, USA. This is an American society devoted to the study and collection of everything related to the daguerreotype. It has a small but growing number of British and European members. Members receive the bimonthly *Daguerreian Society Newsletter* and *The Daguerreian Annual,* a volume of research papers and articles on the subject. This is a substantial publication, worth the subscription on its own, and has, in a very few years, established itself as one of the leading platforms for the publication of new perspectives on the history and development of the daguerreotype.

134

Acknowledgements

Although the author's name is given prominence on the cover of a book, no project as wide-ranging as this could be the work of just one person. I am, therefore, indebted to the many librarians, curators, dealers and fellow collectors who have generously contributed their time, their expertise and their support to my endeavours. If I do not list names, then everyone will know that their help was equally important.

However, I must make special reference to David Kilpatrick and Ed Buziak, respective editors of *Photon* and *Darkroom User* magazines, whose sustained commitment to publishing my regular historical offerings has created the opportunity for a very great deal of interesting and original research. A substantial proportion of the material in this book was either researched specifically for articles commissioned by those two magazines or was lighted upon fortuitously during searches of various early photographic journals in the quest for quite different material.

All the illustrations come from my own collection except: George Washington Wilson's printing works on page 51, reproduced by kind permission of Aberdeen City Libraries and Cultural Services, and the Dubroni camera outfit on page 75, reproduced by courtesy of Christies, South Kensington.

John Hannavy, Standish, 1997.

'Standish: Parish Church and Stocks' photographed c.1900 by Frederick Dew; gelatine dry plate.

Index